Balthus

Drawings and Watercolors

Giovanni Carandente

Balthus

Drawings and Watercolors

A New York Graphic Society Book

Little, Brown and Company

Boston

International Standard Book Number: 0-8212-1529-9
Library of Congress Catalog Card Number 82-63021

First United States edition

Printed and bound in Italy

New York Graphic Society books are published by
Little, Brown and Company.

Contents

Introduction

'In every work of art', John Rewald has written about the drawings of Balthus, 'there is, next to what is said, that which remains unsaid, is implied, and thus invites us to an endless and silent intercourse with its creator. While it may seem comparatively easy to describe or analyze what is explicitly stated by the artist, it is a much more hazardous task to explore what has not been spelled out.'[1]

These words of an eminent American scholar seem to encapsulate better than any others the right approach to Balthus' art and in particular to his remarkable drawings, superb both in quality and consistency, classical yet resonant with romantic overtones, limpid while being full of secret uncertainties. Literature, eros, learning, poetry and nature commingle in a sort of continuous vortex, in an endless creative flow, inspiring and sustaining this great artist's life. In his drawing, Balthus attains the highest peaks of the great French tradition. Courbet and Cézanne, Seurat and the 'French' Picasso in his *période rose* are among the few names in modern art which can be placed in the same class. The tremulous, disquieting emotion which emanates from the pages where Balthus has, with pen, pencil, pastels or watercolour, set down his compositional ideas – be they preparatory studies for paintings, investigations into the rapport between figures or things and space, or enquiries into the quality of light gilding a landscape or moulding the contours of an adolescent girl or a piece of fruit – is one of the hardest to translate into words because, even while it can be instinctively grasped and understood, it remains utterly mysterious to our rational selves, suspended between contemplation of its rapt beauty and a desire to fathom its impenetrable and secret depths.

When people have written about Balthus, he has always preferred that they should keep away from biographical data and refrain from dwelling on external facets of his private life, and we too will follow this principle. 'Man the unknown' (to borrow Alexis Carrel's title) can very well be left undisturbed by anyone wishing to learn about Balthus the artist. The artist, for his part, will not fail to convey through his works a palpable impression of civilized refinement and cultivated human dignity, thereby providing as true a portrait as any of the man himself. As to the history of Balthus' professional achievements, this book (which was originally produced as the catalogue of the Spoleto exhibition 'Balthus: disegni e acquarelli', 1982) covers almost the entire range of his graphic work, from his very earliest drawings to those completed in 1982. The number of Balthus exhibitions that have been held throughout the world can – as Jean Leymarie wrote in the catalogue of the 1980 Venice Biennale – be counted on the fingers of one hand; and the Biennale show, which Luigi Carluccio organized with such diligence and enthusiasm, featured only paintings. Opportunities to see the artist's drawings and watercolours have been even rarer, and only three shows (New York 1963, Paris 1971 and Chicago 1981)[2] may be said to have carried a fair sample. The Spoleto exhibition, therefore, has broken fresh ground.

Despite many difficulties, it has been possible here to give a highly comprehensive view of Balthus the draughtsman and colourist, starting with that astonishing revelation *The Angel's Message to the Knight of Strättligen* (no. 1). The artist executed it when he was thirteen, as a project for a fresco which he wished to paint (but was not permitted to) in an old chapel in the Swiss village of Einigen on the Lake of Thun. Never reproduced until now, this work tells us something of what has hitherto remained Balthus' pre-history, artistically speaking (it is a distant echo of Raphael's *Vision of a Knight*, seen through the image of the *genius loci*), and also provides us with incontrovertible evidence of his precocious talents: there is already the unmistakable 'Balthus colour' and 'Balthus light', of which Antonin Artaud was to speak in 1936.

The poet Rainer Maria Rilke was the first to become interested in Balthus the infant prodigy. At roughly the same time as the *Angel's Message*, and after he had had a visit from Balthus at Beatenberg, Rilke wrote of the surprising insight displayed by the boy into the world of oriental form, an element in Balthus' art perhaps more affinitive than intellectual – and one which he has retained to the present day, although manifesting it only intermittently.

Another element has been literature, good literature in the English language. The critic John Russell says that reading for Balthus has been 'one of the supreme activities' and adds perspicaciously that not only was the act of reading important to him 'but the *look* of the act of reading',[3] which from the start has recurred so often as a theme in his pictures.

In addition to these influences from north and east, Balthus' art has always been imbued with a profound and pondered perception of the early Italian Renaissance. Piero della Francesca is known to have been a determining influence in Balthus' formative years and, together with the grand tour which Balthus made of Italian cities to study the country's artistic heritage, must have contributed much towards perfecting his instinctive classicism of design. The triple study for a *Self-portrait* (no. 2), another revelation of his early work, discovered and acquired by Sabine Rewald, is intended to be in the Caesarian fashion, the profile being within the circle of a medal with a hint of a dedicatory inscription, in the romantic style favoured by Ludwig of Bavaria, as if Balthus at that time were already acquainted with Imperial epigraphy and Roman coins.

The histories of great artists abound with accounts of their precocious insights, and Balthus is no exception to the rule. As an example we may take one of his famous paintings, the first version of *The Street* (1929),[4] to which the drawing reproduced here relates (no. 3). The sketch discloses in its incisive strokes the planned perspective of the composition. John Russell has pointed out the parallel between the carpenter carrying the wooden plank obliquely on his shoulders and a similar figure in *The Removal of the Sacred Bridge* at Arezzo. But an even more noteworthy touch is the transformation of a busy, bourgeois Paris street into an immemorial scene. As in Piero della Francesca's *Legend of the True Cross*, the people stand as if petrified and solemn, with that 'weighing

Self-portrait, 1942
Pencil and charcoal, 43 × 33.5 (16⅞ × 13¼)
Formerly Collection Pierre Matisse,
New York; stolen in 1967

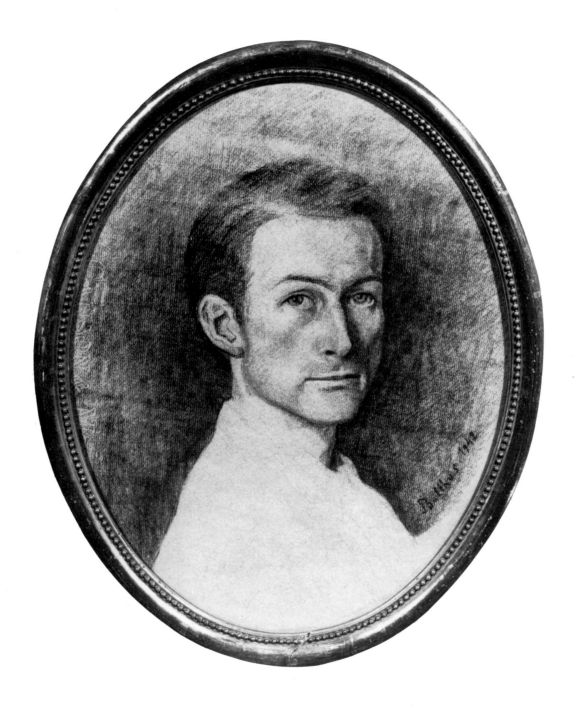

of sun-motes practised by Seurat' described by Roberto Longhi in his well-known essay on Piero; this is visible even in the drawing. The academic drawings of the young Seurat, done before 1880, had that same firmness of line, those dense, silken blacks, those well-defined corporeal masses. Seurat was to remain one of Balthus' few ardent loves.

It was on his return from Morocco that Balthus began applying himself furiously to an unusual enterprise for which he had already, before his departure for North Africa, done some sporadic drawings: a set of illustrations for Emily Brontë's novel *Wuthering Heights*, the book which Chesterton said could have been written by an eagle. The complete definitive series comprises fourteen drawings, all now in one collection in France, and is reproduced here (nos 4–17), in its correct narrative sequence, for the first time. At a certain point the project was interrupted, and the book never appeared with these illustrations.

The fourteen illustrations were preceded and accompanied by a large number of studies, sometimes repetitions, sometimes variants, or else concerned with other episodes in the novel. We have assembled as many of these as possible in order to demonstrate the profound interest taken by Balthus during his early years in the gripping and dramatic story of Heathcliff and Cathy.[5] (Nos 18–26).

Another drawing (no. 27), not in the series but directly related to it, was a preparatory study for *Cathy dressing* and was executed in the same year (1933). As is clear from its counterpart in the series (no. 12) and the previous drawing, the artist identified closely with the hero of *Wuthering Heights* (as did Delacroix with Hamlet) and depicted himself in Heathcliff's clothes. The likeness can be seen, too, in numerous other drawings of the series.

John Russell tells us that Balthus read *Wuthering Heights* at the age of fourteen and relates how, on the conclusion of his military service some years later, memories of the novel oppressed him with 'almost hallucinatory force'. The character of Heathcliff fascinated him in particular – not so much Heathcliff the mature man on his return to Wuthering Heights but the wild and surly young Heathcliff in the first part of the tale as the housekeeper Nelly Dean describes him to Mr Lockwood, Heathcliff as Cathy's playmate and admirer, before and after the ferocious dog bit her, and after the Lintons had transformed her into an elegant young lady, until the moment of her dramatic death – all of which one sees depicted with such dynamic and stark force in these drawings.

The last picture in the series (no. 17), which is also the most powerful, illustrates the part of Nelly Dean's story where she recalls how 'Catherine's arms had fallen relaxed and her head hung down.' Heathcliff holds her in his arms, despair on his face. Just a few hours later, Cathy was to die.

The series of drawings stopped at that point and, like Ellis Bell (Emily Brontë's pseudonym), is surrounded by mystery. Where did it come from, Balthus' fascination with the highly individual

characters of *Wuthering Heights*? What impulse caused him to depict these characters, so solid and strong, in bare interiors or on the windswept moor, sixty miles from Liverpool but a thousand miles from the Parisian milieu where he had now gained an entrée under protection of the most influential patrons? How did it arise, this close identification with the fictional character of Heathcliff? Again to quote John Russell, these drawings have 'the character of a private diary which we feel it is hardly for us to open'. As a matter of pure artistic record, however, we may observe that the themes and motifs – not to mention the essential quality – of this series were to re-emerge later in Balthus' painting and also in many of his drawings.

Two years after their execution, eight of the fourteen definitive drawings were published without comment by the review *Minotaure*, in an issue devoted to the nocturnal aspect of nature.[6] From then on, apart from Russell's writing, they have been accorded only brief mention. Certainly these illustrations have a special significance in Balthus' work. They constitute a vigorous and at the same time romantic chapter, in which can be discerned clear stylistic echoes from Delacroix and from William Blake (the *Songs of Innocence* and *Milton*), but always retaining Balthus' strong individual stamp.

With his knowledge of the English language, Balthus could also enjoy the nuances of Lewis Carroll's works in the original. John Russell has made a comparison between certain adolescent figures drawn or painted by Balthus and some of the forty-two illustrations done by Sir John Tenniel in 1865 for *Alice's Adventures in Wonderland* and *Through the Looking-glass*;[7] and in the catalogue for the Balthus exhibition at the Tate Gallery in 1968 Russell printed the Tenniel drawing of Alice in an armchair playing with a cat and a ball of worsted which illustrates the first chapter of *Through the Looking-glass*. The motif of a young girl in a state which often passes from play to drowsiness, from torpor into trance, recurs many times in Balthus' iconography. It is not suggested that Balthus was actually influenced by Tenniel, just as one cannot – as Russell points out – talk about Tenniel being influenced by Dürer because of the resemblance of his *White Knight* (in Chapter 8 of the same book) to Dürer's woodcut *Der Reuter* (*Knight, Death and the Devil*) of 1513. It is just that in the history of art some coincidences cannot be overlooked. One could cite other similarities between Balthus and Tenniel: for instance, the Piero-della-Francesca-type dwarf who pulls back the curtain in *The Room* of 1954 (see also preparatory drawing, no. 40) appears almost as a caricature of Tenniel's Alice in the first chapter of her adventures ('Down the Rabbit Hole') where she draws aside the curtain and discovers the little door leading to the immortal garden. In Balthus' enchanting picture, the 'immortal garden' is surely that golden light which washes over the adolescent nude stretched out on the divan, focusing our attention on the figure's erotic intimacy and wakening the cat, indignant at this intrusion into its luxurious sleep (Lewis Carroll's Cheshire Cat?).

But are these mere coincidences or deliberate references? The answer can only be an evasive one; at most it can point out that in the enigmatic and symbolic iconography of Balthus' works certain references are more literary than visual. Then again, the nude photographs of young girls taken by Lewis Carroll and tinted or reproduced as watercolours by lady artist-colourists (now more widely known through a book by Morton Cohen and a recent exhibition on 'Lewis Carroll and Alice' at the Pierpont Morgan Library in New York)[8] constitute a curious antecedent of much of Balthus' work executed after 1950.[9] Whether the artist was acquainted with these photographs and whether they surfaced from his visual unconscious, it is impossible to say.

The meeting in Paris between Balthus and Antonin Artaud (nos 28, 29) was important to both of them. Writing about *Cathy Dressing*, Artaud volunteered the view that in this painting, which he felt had the realism of Courbet's *Atelier*, 'the artist has used reality the better to crucify it', transposing our random everyday actions, or rather replacing them and reinventing them pictorially. To gain a fuller understanding of the impact of the work, he bade us 'imagine the metamorphosis of the artist's model into a sphinx'.

Balthus at that time had his first one-man show (13–28 April 1934) at the famous Galerie Pierre, owned by Pierre Loeb, which was aptly dubbed by Jean Leymarie 'le foyer du Surréalisme'. Artaud at once confirmed this description when he wrote in *La nouvelle revue française*: 'It would seem that painting is tired of going berserk, on the one hand, and poring over embryonic matter, on the other. Painting seems to be turning towards a kind of organic realism. So far from rejecting poetry, symbolic storytelling, and all that goes beyond normal experience, painting will be more than ever preoccupied with these things: and it will have surer ways of achieving them.'

The encounter between the poet and the painter soon led to a collaboration which caused a stir. The following year, Artaud put on his play *The Cenci* (based on Shelley and Stendhal) with sets by Balthus, at the Théâtre des Folies Wagram. 'With this production', André Berne Joffroy has recalled recently, the poet 'tried to rouse the spectator, to involve him forcibly in the action, imposing on him, beyond any sense of Good or Bad, a universal sense of life, as in the ancient Eleusinian mysteries'.[10]

Balthus' sketches for *The Cenci* (nos 30–32) reveal the importance he attached to the play's Italian subject, and both Bibbliena and Piranesi are brought readily to mind by the bold inking and the feeling of space. The poet Pierre Jean Jouve, too, wrote of that 'prodigious space', of an interior which was at the same time symbolic and Italian, simple and strong.

The sets for *The Cenci* were not Balthus' only experience of the theatre. In the previous year he had designed the sets for a production of *As You Like It* at the Théâtre des Champs-Elysées. Later he did the designs for *L'état de siège* by Albert Camus, for *L'isola delle capre* by Ugo Betti, for Jean-Louis Barrault's production of *Julius Caesar*, and, lastly, in 1950, for the Festival d'Aix-

en-Provence, *Così fan tutte*. It would have given us great pleasure to reconstruct this interesting chapter in Balthus' career, his association with the theatre – a chapter not yet properly studied and remaining almost unknown except to those fortunate enough to have seen the productions in question. As it is, we have succeeded in recovering only some originals done for *The Cenci* and for the Mozart opera. From the other productions all has been lost and no trace can be found of the original drawings. In this connection, it is worth turning once again to John Rewald's introduction to the E. V. Thaw exhibition catalogue:

'I remember a visit to Balthus' Parisian studio, some twelve years ago, where he was at pains to satisfy my wish to see his drawings. A number of them were strewn on the floor where they had been walked over to such an extent that they were no longer presentable. Searching in drawers, portfolios, and even under a bed, he finally was able to assemble a few, and they were magnificent. The negligence with which he handled them is the hallmark of the true artist, for notwithstanding his self-consciousness and the assurance with which he hides his timidity, Balthus is not easily satisfied with what he does. To the contrary, he treats his work with the severity of a very demanding creator. He is neither complacent nor frivolous – though he occasionally likes to appear flippant – but is dedicated to his task and always critical of what he seems to produce with apparent facility. To draw may be easy for him (as it must have been for Delacroix), yet easily obtained results do not retain his attention. Most of his drawings are preparatory studies for compositions, working sheets, so to speak, in which he loses interest as soon as they have been transposed to paintings.'[11]

It is difficult to say how much of Balthus' graphic work has been irremediably lost, and the destruction is scarcely made up for by what happily remains; of the artist's output until the start of the 1960s we have gathered together perhaps just over half of what survives. In 1961 he was invited by André Malraux to run the Académie de France at the Villa Medici in Rome, and from this time his drawing activities intensified so that Claude Bernard was able, in 1971, to mount an exhibition in Paris showing a fair number of his watercolours and drawings, all of recent date. Since then, the entire corpus of Balthus' work, much of it comprising repetitions of the same motif, has been preserved.

The American critic James Thrall Soby acquired the second version of the painting *The Street* (1933–35) as soon as it had been put on display at the Galerie Pierre. Not long after, Pierre Matisse took up Balthus, who thereupon became one of the most sought-after artists in the United States. The first showing of his works at the Pierre Matisse Gallery in New York took place in 1938 and was followed by many others. In 1956, Soby mounted the first Balthus exhibition to be held at the Museum of Modern Art. The only drawings included on that occasion were the series of fourteen for *Wuthering Heights*. Balthus also attracted the favourable attention of Picasso, who acquired *The Children* (1937) for his private collection. (It has now passed, as part of the Picasso donation,

to the Louvre.) Reproduced here are two studies bearing indirectly on that work (nos 33, 34). Of the only openly erotic painting by Balthus, entitled *The Guitar Lesson* (1934), today in the Museum of Modern Art, we show here a *d'après* of 1949 (no. 45). In this drawing and in the two studies relating to *The Children*, we see an editorial process in operation where the graphic works differ completely from the paintings, and this prompts an important observation about the connection between the drawings and the paintings. Where the former are preliminary studies, it seems that the artist, initially, is trying out the individual characters in the intended work, analysing each in its spatial context and delineating each in accordance with some overall plan known only to himself. His strokes are sure and exact (the two drawings relating to *The Children* have a concise purity of line and a perspective of the utmost solidity), and the torsion of the image is calibrated in a way which gives us to understand that the artist already knows all the things that will be occurring simultaneously in the completed picture. There is a striking difference between the drawing after *The Guitar Lesson* and the original painting (done fifteen years earlier). In place of the woman caressing her friend like an exquisite musical instrument, we have a man. However, Balthus considers the eroticism in his work to be sacred and for this reason he likes it to be neither publicized nor commented on.

There exists another drawing (in the collection of the painter Botero in Paris), which is a preliminary sketch for *The Guitar Lesson* and features just one of the female figures (as in the drawings relating to *The Children*), providing additional evidence of the deep and complex thought underlying the whole of this artist's creative activity. One of our Italian poets, Piero Bigongiari, has given a good account of the number of variations Balthus could produce during the long, distillatory process of painting.

This helps us to understand the indifference with which the artist at the beginning treated these *carnets*, these working studies for what were – for him – his loftiest achievements. But, as this book demonstrates abundantly, the drawings which have been miraculously spared for us are of such an exceptionally high quality and coherence as to constitute – in common with sketches made by the old masters and certain other great artists of our time – finished works in their own right, often with those most valued traits of the genre: immediacy and spontaneity.

The places where Balthus has resided over the years have been a source of inspiration to him and have featured in his painting as the adolescent models, the portrait subjects, the conversation pieces and the still-lifes. In his drawings and watercolours too, landscape becomes a great 'life in motion', animated from plain to hill, from the window overlooking the farmhouse to the open mountainside, with human beings, houses, animals, objects, in an atmospheric light so personal to Balthus as to have remained unaltered from his first pictures of Savoy, or the Morvan district in central France, to the recent soft-focused views of the Latium village, Monte Calvello.

Just one oil painting (no. 49) was included in the exhibition, and the choice is symbolic. Balthus painted it in 1951, and Albert Camus – to whom it then belonged – wrote a memorable piece about it.[12] Its title is quite simply *Paysage d'Italie* and it is a tribute from Balthus to that Italian figurative tradition which runs from Giotto to Annibale Carracci. The picture was done from the top of the Castello Caetani at Sermoneta and shows the valley (with the ruined church of the Madonna del Monte in the centre) winding between the hills of Sermoneta and the Lepini mountains – of which one can just see the first slopes – with rows of olive trees and *maceroni*, low walls of uncemented native rock used for marking the property boundaries.

The haunting atmosphere and poetic quality of this panoramic view are such as to evoke the magic of Dante's lines (*Purgatorio*, VII, 70–72):

> *Tra erto e piano era un sentiero sghembo*
> *Che ne condusse in fianco della valle*
> *Là dove più ch'a mezzo muore il lembo*

('. . . and here a pathway fell/At times, or levelled as it wound, from which,/Half downward now, the valley's floor we viewed.' *The Purgatorio*, trs. S. F. Wright, Edinburgh and London, Oliver and Boyd, 1954.)

Quite simply, it is a landscape which synthesizes an entire pictorial tradition. We are most grateful to the present owners for the loan of it; it was shown in the Spoleto exhibition and reproduced here as a small return for the compliment paid by Balthus to an artistic civilization which he has found so congenial and of which he has evinced such a deep love and understanding.

Besides the undeniable links with Cézanne which are visible in the watercolour still-lifes, it is Courbet who is repeatedly mentioned by critics as Balthus' truest spiritual ancestor. J. T. Soby, for example, saw in the two children in Courbet's *Portrait of P. J. Proud'hon and his Children* (1865) the forerunners of the adolescent figures with languid poses and bowed heads who feature in many Balthus paintings and drawings of the 1930s and 1940s. Russell compares *The Mountain* of 1936 (Metropolitan Museum of Art, New York) with Courbet's *The Young Ladies of the Village* painted in 1851 and, in commenting on the crystalline purity of the picture's background, invokes the German philosopher Carl Gustav Carus (according to whom nature forms a whole, of which man is but a part) and the Romantic painter Caspar David Friedrich. One could also, as M. H. Ravalli has suggested, connect this great Alpine painting with *A Climber* (c. 1912) by the Danish artist J. F. Willumsen,[13] but for Balthus' denial of ever having seen that picture. Another parallel has been drawn between Balthus' work, especially the landscapes of Savoy and the Morvan, and that of Poussin.

For Balthus, however, the works of others are at the most antecedents, never actual sources of inspiration. When an artist possesses such a strength of invention and such a high charge of internal motivation, comparisons are of limited relevance.

As others have mentioned before, Balthus appears many times in his own early works, either face on or from behind (that is to say candidly or cryptically), and in drawings or paintings of particular autobiographical significance he himself is often the protagonist; in this respect he follows Leonardo. Apart from the drawings for *Wuthering Heights*, the artist's likeness may be seen in paintings such as *The Quays* (1929), *Cathy Dressing* (1933), *The Golden Days* (1944–46) and perhaps also in *Le passage du Commerce Saint-André* (1952–54). Of painted self-portraits *per se*, we know of only one small example dated 1949–50 and another, somewhat earlier, which the artist has recently taken back and largely repainted. In drawings, the artist has been rather more open-handed with his own image. Besides the early triple study reproduced here, we know of another work: a charcoal drawing, in a private Swiss collection, showing the artist in his teens. Belonging to a later period are two *Self-portraits* of the highest quality: the first, done in 1942, was stolen from Pierre Matisse's gallery in New York during the 1967 exhibition on the very day it closed – 22 April – and we reproduce it in this book (on p. 9), hoping thereby to assist in its retrieval. In this work and in that of 1943 (no. 36), Balthus may be seen as a true scion of the great French school of drawing, an emulator of Ingres and the early Degas. There is an extraordinary psychological vividness and intensity in both portraits, and the spare sobriety of the image cloaks a wealth of unspoken and implicit meaning.

What strikes one generally about Balthus' drawing is that he penetrates the object of his work with a force and a desire for truth quite surpassing the usual concept of realism. He sees before him a face, his own reflected in a mirror, or somebody else's, an unforgettable angelic or timorously sensual female figure, or else, perhaps, a vase of flowers or some apples – and to all these real and tangible things he subordinates himself, yet at the same time adding his own intimate viewpoint, his own method of looking at people and objects, his own poetic dream. These living beings or flowers, even though scrutinized in all their evident reality, thus assume an emblematic aspect which transports them to another sphere, the private and personal sphere of the artist, far from the world of their own origin. In modern art, only Marino Marini, with his famous gallery of sculpted portraits, has been able to equal Balthus in reconciling independence from the subject matter with a total submission to it. For Balthus, as for Marini, visual likeness is a completely secondary consideration, even while remaining an ineradicable nesessity.

In the 1940s and 1950s, Balthus' drawings and watercolours were largely preparatory studies for his paintings, executed as part of a characteristically lengthy gestation period. To this category belong Balthus' graphic ideas for *La tireuse de cartes* (a young girl who could be either playing

patience or reading the cards, a possible memory of Caravaggio's *Fortune-teller*, *c.* 1593), *Nude in front of a Mantle*, *Nude with Cat*, *The Room*, *Le passage du Commerce Saint-André*, *The Dream* and *The Three Sisters*; that is to say, the studies for some of his celebrated masterpieces of those two decades and the 1960s. It can be seen that between the first setting down of ideas in the form of drawing or watercolour and the final, completed picture there often elapsed an interval of years – further evidence of this artist's slow and meditated method of working.

In 1950 Balthus carried out his designs for *Così fan tutte*, and the watercolour scene shown here (no. 46) is one of several which he did for the sets. We have also managed to obtain one of his costume designs (no. 48). The setting of the opera against the Bay of Naples is enclosed as though within the valves of a shell, transforming it into an imaginary and at the same time identifiable place – a memorable theatrical scene, created in fresh and delicate colours and in a graceful style which is undoubtedly a conscious tribute to Mozart. For all the centuries that artists have busied themselves depicting Vesuvius and its environs in the most varied of lights and perspectives, no Parthenopean vista has ever been rendered in such unusual and poetically innovative terms.

When Balthus puts colour to paper he uses what John Rewald calls accents of subtle ornamentation, directed however towards the most absolute verisimilitude. The still-lifes carried out during his stay at Chassy in the later 1950s, in particular the flowers and fruit, are of an unequalled magnificence, as are the landscapes of the same period, a comprehensive selection of which is reproduced here. It is in fact from this middle period that we have been able most easily to track down key drawings and watercolours.

In 1961 Balthus moved to Rome, and from then on his drawings and watercolours have often reflected the places where they were created: for the most part Rome and, later, Monte Calvello, the ancient fief of the Doria Pamphili where he has made his summer residence. As a successor to Ingres at the Villa Medici, walking in the gardens where Velazquez painted, seeing framed in the windows the view made famous by Corot, Balthus found himself in surroundings very sympathetic to his art. Having previously looked on drawing merely as a means to an end for painting, he now began devoting himself more intensively to graphic work and finally came to consider drawing as an activity in its own right. Of his output during this period, we believe we have gathered the best selection. In the Ingresque purity of certain drawings done in 1963, often on lightly tinted paper, or on Elephanthide paper with its network of striations and a bistre, ivory or greenish tint; in the oriental subjects which, starting from *The Turkish Room*, lead through to the almost sacred theme of *La Japonaise*; and in those voluptuous images of young girls which inspired René Char to speak of 'la caresse de cette guêpe matinale que les abeilles désignent du nom de jeune fille et qui cache dans son corsage la clé de Balthus', the artist's work has rediscovered a southern, Mediterranean light – a light which still shines.

Notes

1 'Thoughts on Drawings by Balthus' in *Drawings by Balthus* (exh. cat.), New York 1963 (see Bibliography, p. 118).

2 The New York exhibition, 'Drawings by Balthus', was held at the E. V. Thaw Gallery, 26 November – 21 December 1963. John Rewald wrote the introduction to the catalogue ('Thoughts on Drawings by Balthus'). The exhibition comprised fifty-five drawings and watercolours from 1929 (illustration no. 3 in this book was dated 1928 in that catalogue) to 1962.

Another exhibition consisting of drawings by Giacometti and Balthus was held in New York in 1966 (with fifty-five Balthus drawings) at the Albert Loeb and Krugier Inc. Gallery (catalogue with introduction by James Lord, see Bibliography, p. 118).

The Paris exhibition, 'Balthus, Dessins et Aquarelles', was held at the Galerie Claude Bernard in October 1971, and Jean Leymarie wrote the introduction. It consisted of sixty-seven drawings and watercolours, of which nos 2, 15, 16, 22, 38, 54, 57 and 61 were included in the Spoleto exhibition.

The Chicago exhibition, 'Balthus in Chicago', was held in 1981 at the Museum of Contemporary Art. It comprised thirty-four drawings and watercolours, together with six paintings. The catalogue contained no critical essay but printed a biographical note as a preface to the illustrations of seven drawings.

Since 1938 the Pierre Matisse Gallery in New York has given seven showings of Balthus's work, often hanging drawings and watercolours next to the relevant pictures. The exhibition of 1967 (28 March – 22 April) showed twenty-seven drawings, including the *Self-portrait* of 1942 (reproduced here on page 9). The same exhibition showed the paintings *The Turkish Room* and all three versions of *The Three Sisters*.

Drawings were also hung next to the relevant paintings at the London Tate Gallery Exhibition of 1968, arranged by John Russell, in which thirty-nine drawings and watercolours were included, and at the Musée Cantini exhibition at Marseilles in 1973, where the introduction was written by Jean Leymarie (twenty-five drawings and watercolours included). Some of the drawings reproduced here were seen at both those exhibitions, and we have indicated which in the individual captions. An exhibition containing a few drawings and watercolours was held in 1975 at the Galerie Arts Anciens, Bevaix (see Bibliography, p. 118).

3 Introduction to *Balthus* (exh. cat.), London 1968 (see Bibliography, p. 118).

4 Collection Cook, New York. The second version, 1933–35, is now in the Museum of Modern Art, bequeathed by James Thrall Soby.

5 Not one of the drawings for *Wuthering Heights* done before Balthus' departure for Morocco has survived. Apart from the definitive series and the further twelve reproduced here, few others are known of. We give here a list of them, so far as we have been able to compile one from catalogues of shows held at private galleries. One drawing, depicting a girl in a long white dress with a book in her hand, which is reproduced in the catalogue of an exhibition held in 1966 at the Bud Holland Gallery, Chicago, and is described there as a study for *Wuthering Heights*, is in fact a preparatory study for the 1935 painting *Portrait of Lady with Book*, now at the Georg Waechter Memorial Foundation, Geneva. The others are: a sketch of Heathcliff and Cathy on the moor, private collection, Chicago (in the above-mentioned Bud Holland catalogue); a drawing of Heathcliff and Cathy escaping, Collection Kannenstine, New York (E. V. Thaw catalogue, 1963, no. 5); a drawing of Cathy and Heathcliff after Edgar and Heathcliff's violent quarrel, private collection, New York Rewald, (E. V. Thaw catalogue, 1963, no. 6); a drawing of Heathcliff and Cathy near a tree, private collection, Munich (Rewald, E. V. Thaw catalogue, 1963, no. 8).

6 *Minotaure*, Paris, Albert Skira, II, no. 7, 10 June 1935, pp. 60–61.

7 They are reproduced in their entirety in *Alice Drawings by Sir John Tenniel for Alice's Adventures in Wonderland and Through the Looking-glass*, Harvard, Dept. of Printing and Graphic Arts, Harvard College Library in association with the Metropolitan Museum of Art, 1978. It is of some interest to recall that Marie Laurencin also illustrated *Alice in Wonderland* in 1930.

8 Morton N. Cohen, *Lewis Carroll and Alice, 1832–1982* (exh. cat.) New York 1982.

9 For Lewis Carroll as a photographer, see Helmut Gernsheim, *Lewis Carroll Photographer*, with sixty-three photographs by L. C., New York, Dover, 1969, and Morton N. Cohen, *Lewis Carroll, Photographer of Children. Four Nude Studies*, Philadelphia, Rosenbach Museum and Library, 1979. See also Franco Maria Ricci, *Le bambine di Carroll, foto e lettere*, ed. Guido Almansi, 1974, and Helmut Gernsheim, *Lewis Carroll: Victorian Photographer*, London, Thames and Hudson, 1980. See also *Lewis Carroll: A Celebration, Essays on the Occasion of the 150th Anniversary of the Birth of Charles Lutwidge Dodgson* (by various authors), ed. Edward Giuliano, New York, Clarkson N. Potter, 1981.

10 André Berne Joffroy, 'Cette exposition. . . .', introduction to the catalogue of the exhibition 'L'Aventure de Pierre Loeb. La Galerie Pierre, Paris 1924–1964', Musée d'Art Moderne de la Ville de Paris and Musée d'Ixelles, Brussels, 1979 (see Bibliography, p. 118).

11 'Thoughts on Drawings by Balthus', in *Drawings by Balthus*, New York 1963 (see Bibliography, p. 118).

12 In *Verve*, no. 27–28, 1952 (see Bibliography, p. 118).

13 Jens Ferdinand Willumsen, who was born in Copenhagen in 1863 and died there in the 1950s, lived for a long time in Paris. The painting *A Climber* (*En Bjergbestigerske* – literally 'a woman climber'), *c.* 1912, variant of another treating the same subject in 1904, is in the Museum of Modern Art in Copenhagen.

Drawings and Watercolours

1 *The Angel's Message to the Knight of Strättligen*, 1921
Tempera on paper, 155 × 148 (61 × 58¼)
Private collection, Berne

To date, this is the artist's earliest known surviving work, completed when he was just thirteen. It is a study for a fresco which he wanted to paint in the chapel of Einigen on the Lake of Thun. The subject deals with the legend attached to the founding of this little 10th-century church, one of the oldest in Switzerland. The artist already shows a deep knowledge of the early Italian Renaissance, as well as of the Gothic courtly style at the time of Jean, Duc de Berry. But, more importantly, the picture has been done in a popular and traditional vein appropriate to the setting. In fact, Balthus confirms that, as a boy, he admired and copied the frescoes of popular traditional painters to be seen in various little churches in the canton of Valais. In particular, he was fascinated by the piquant narrative quality in Joseph Reinhardt's work (Lucerne, 1749–1829), which is especially evident in his depictions of peasant costumes of the Swiss cantons, now in the Historisches Museum in Berne (cf. Julie Heierli, *Die Volkstrachten der Schweiz*, 5 vols, Erlenbach-Zürich 1922–32).

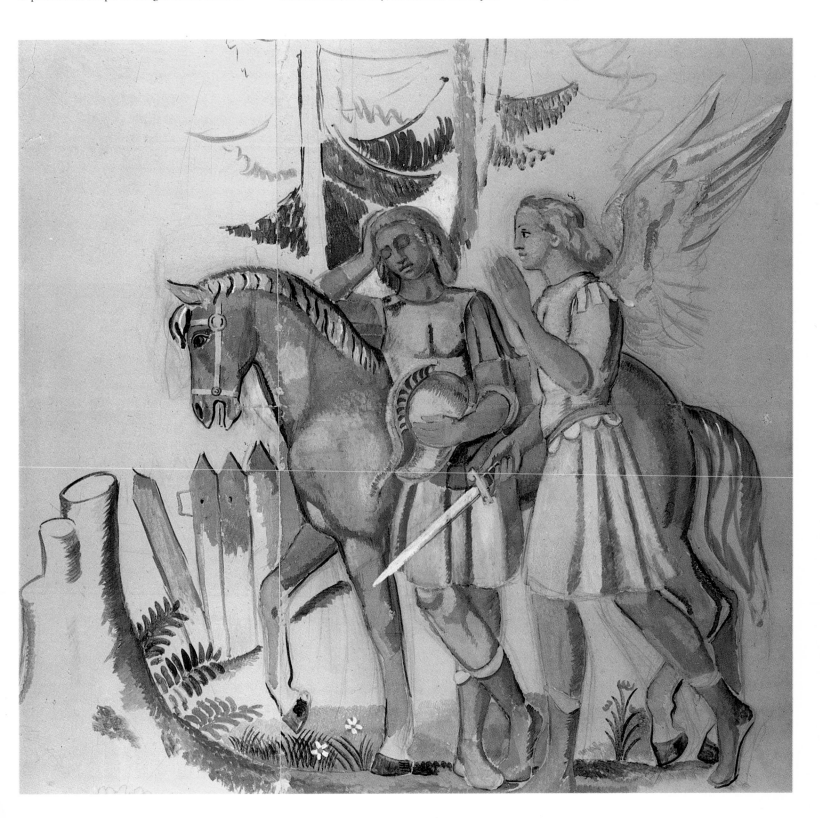

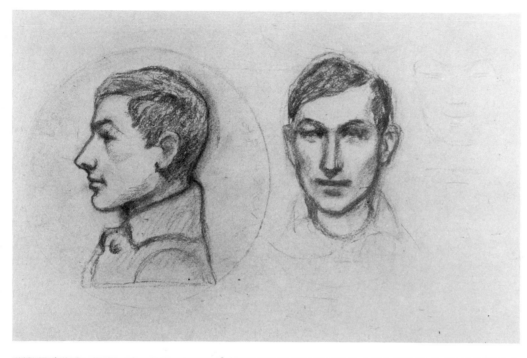

2 Three studies for a *Self-portrait*, c.1923
Pencil and charcoal on yellowish paper,
30 × 42 (11¾ × 16 ½)
Collection Sabine Rewald, New York

The profile, enclosed in a circle in the manner of
an ancient medal, bears traces of writing round
the border. Sabine Rewald contends with
justification that these studies, among the earliest
known depicting the artist as a young man, must
have been drawn at Beatenberg near the Lake of
Thun in Switzerland, where Balthus and his
father used to spend their holidays.

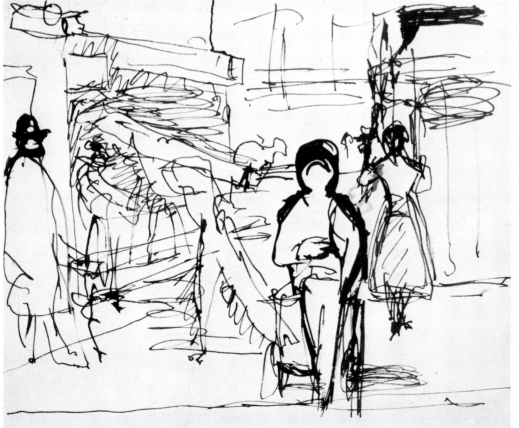

3 Study for the first version of *The Street*, 1929
Pen and Indian ink, 17.4 × 21.8 (6⅞ × 8⅝)
The Museum of Modern Art, New York, gift of
James Thrall Soby, no. 595.63
Repr. exh. cat. Russell, London (no. 61, p. 89)

The first version of the painting (now in the Cook
Collection, New York) was painted the same
year. The second version (1933–35), with
alterations in the number of figures and in the
perspective, was also preceded by numerous
sketches and studies, one of which is on the verso
of the study for *Cathy Dressing* (no. 27).

4 'Frances pulled his hair heartily' (Chapter 3)
49 × 42 (19¼ × 16½)
Repr. *Minotaure*, 1935, no. 7, p. 60

Hindley is seated on the left. His wife Frances is
pulling Heathcliff's hair, while Cathy is curled up
at his feet.

5 *Heathcliff and Cathy* 'Because Cathy taught
him what she learnt' (Chapter 6)
50.4 × 41 (19¾ × 16⅛)
Repr. *Minotaure*, 1935, no. 7, p. 60; Leymarie,
1978

Balthus used the composition of this drawing
again in his painting *The Children* (which has
now passed to the Louvre as part of the Picasso
donation).

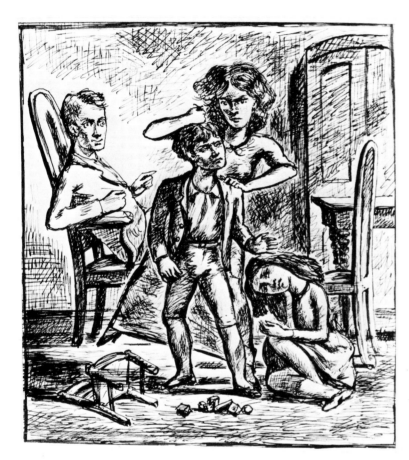

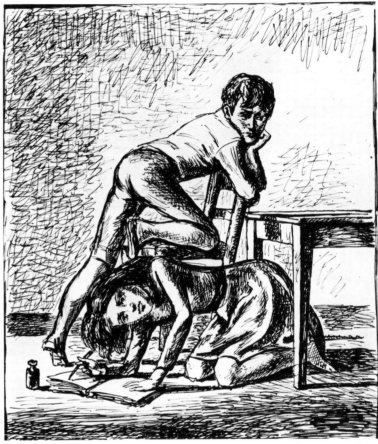

*Definitive series of 14 drawings
planned as illustrations for the novel*
Wuthering Heights *by Emily
Brontë, 1933 (nos 4–17)*

Pen and Indian ink
Private collection, France

6 *Heathcliff and Cathy on the Moor* 'But it was one of their chief amusements to run away to the moors' (Chapter 6)
50.4 × 41 (19¾ × 16⅛)

See also no. 19.

7 *Cathy and Heathcliff Escape from Wuthering Heights* 'Cathy and I escaped from the wash-house to have a ramble at liberty' (Chapter 6)
50.4 × 41 (19¾ × 16⅛)
Repr. *Minotaure*, 1935, no. 7, p. 60; exh. cat. Russell, London 1968 (no. 62, p. 91)

See also no. 24.

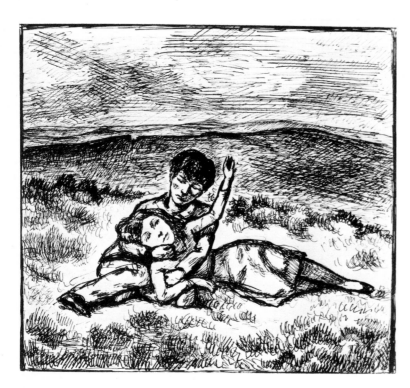

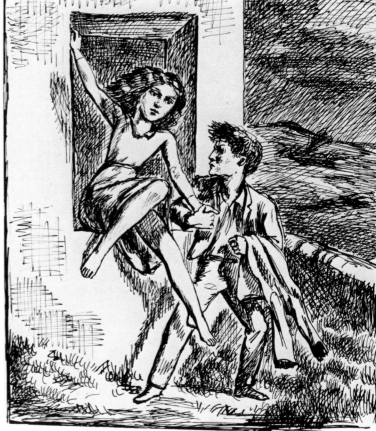

8 *Cathy Bitten by the Dog* 'The devil had seized her ankle' (Chapter 6)
50.4 × 41 (19¾ × 16⅛)
Repr. *Minotaure*, 1935, no. 7, p. 60

See also no. 21.

9 *Cathy Comforted by the Lintons after the Dog had Bitten Her* 'I saw they were full of stupid admiration' (Chapter 6)
50.4 × 41 (19¾ × 16⅛)

On the left are the Linton parents and, on Cathy's right, Isabella and Edgar (Cathy's future husband).

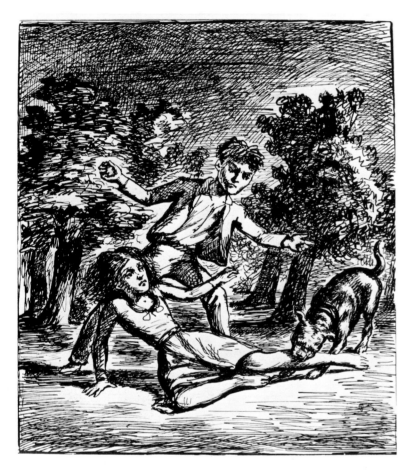

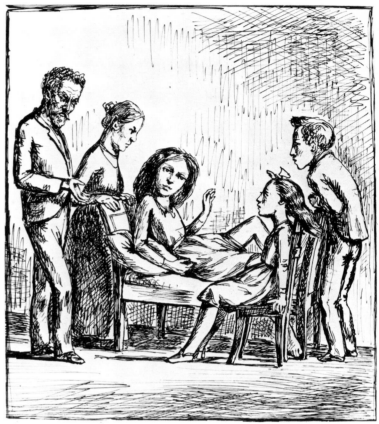

10 'You needn't have touched me' (Chapter 7)
50.3 × 41.2 (19¾ × 16¼)
Repr. *Minotaure*, 1935, no. 7, p. 61; exh. cat.
Russell, London 1968 (no. 62, p. 90)

From left to right the characters are Hindley with
his wife, Cathy and Heathcliff, and the house-
keeper Nelly Dean. The occasion is Cathy's
return home after having recovered from the
dog bite. (See also no. 22.)

11 'Why have you put that silk frock on, then?'
Heathcliff asks Cathy (Chapter 8)
50.3 × 41.2 (19¾ × 16¼)
Repr. *Minotaure*, 1935, no. 7, p. 61

This drawing was the matrix for the painting
Cathy Dressing. (See the comments in the
Introduction.)

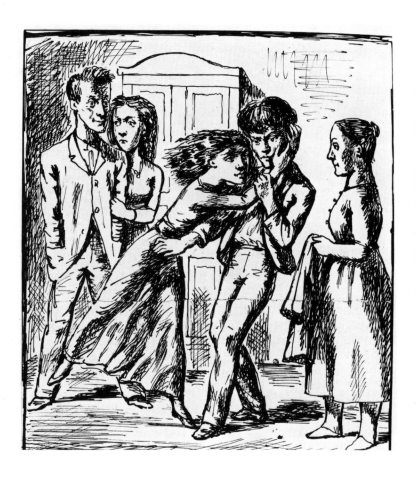

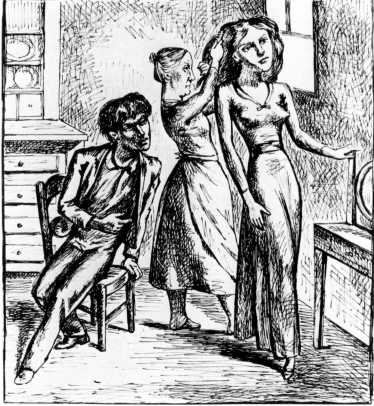

12 'By a natural impulse, he [Heathcliff] arrested his [the child's] descent' (Chapter 9)
50.3 × 41.2 (19¾ × 16¼)

This is one of the most dramatic moments in the novel, in which Heathcliff saves Hindley's child, Hindley in a state of drunkenness having let the little boy fall from his arms.

13 'It would degrade me to marry Heathcliff now; so he shall never know how much I love him' (Chapter 9)
50.4 × 41 (19⅞ × 16⅛)
Repr. *Minotaure*, 1935, no. 7, p. 61

To explain this scene, we must refer to Nelly Dean's story: ''Ere this speech ended, I became

sensible of Heathcliff's presence... He had listened till he heard Catherine say it would degrade her to marry him, and then he stayed to hear no further.' Having left, Heathcliff did not reappear until the drama of Wuthering Heights was approaching its climax. (See also no. 25.)

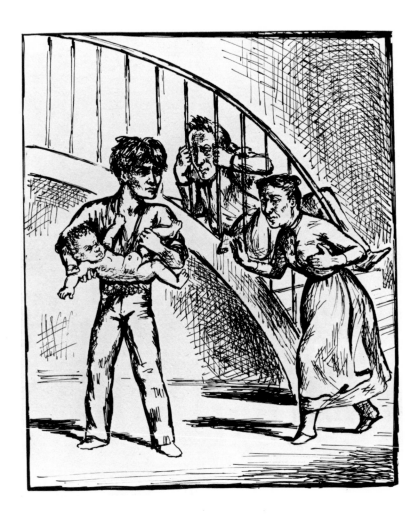

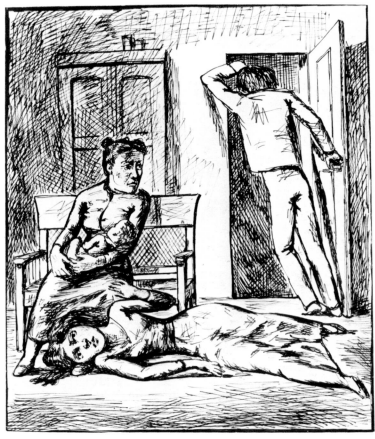

14 *Cathy in the Storm* '. . . excepting Cathy,
who got thoroughly drenched for her obstinacy
in refusing to take shelter, and standing bonnetless
and shawl-less to catch as much water as she
could with her hair and clothes.' (Chapter 9)
50.4 × 41 (19¾ × 16⅛)
Repr. *Minotaure*, 1935, no. 7, p. 61

It was Sabine Rewald who suggested the reference
to this episode in the novel.

15 'No, Isabella, you shan't run off' (Chapter 10)
50.5 × 41.8 (19⅞ × 16½)

Cathy, jealous and cruel, detains Isabella, who
wants to make her escape after Cathy has told
Heathcliff of her sister-in-law's secret love for him.
 The two female figures in this drawing appear
to be bound together in a somewhat enigmatic
relationship which connects them with the two
women in *The Guitar Lesson*, painted the
following year.

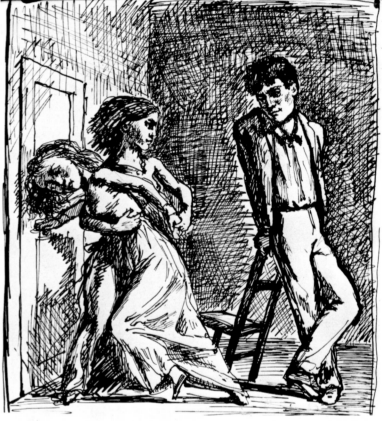

16 'There, you've done with coming here'
(Chapter 11)
50.5 × 41.5 (19⅞ × 16⅜)

This scene takes place just after the violent quarrel
between Cathy's husband and Heathcliff. (See
also no. 20a.)

17 'Catherine's arms had fallen relaxed, and her
head hung down' (Chapter 15)
50.5 × 41.5 (19⅞ × 16⅜)

This is the last episode of Emily Brontë's novel
to be illustrated by Balthus. It is also the high
point of the drama.

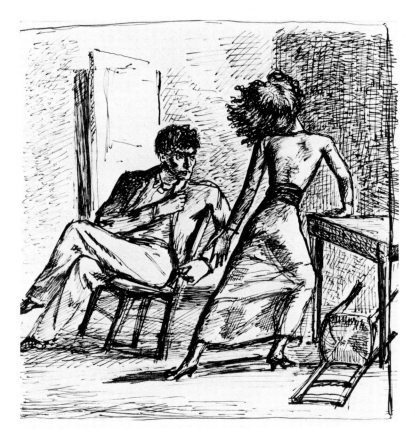

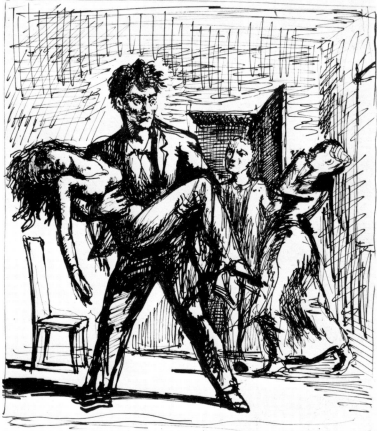

18 a) (recto) 'Oh! Nelly, the room is haunted!
I'm afraid of being alone' (Chapter 12)
Pen and Indian ink, 30 × 28.5 (11¾ × 11¼)

See also nos 23 and 26.

b) (verso) 'Miss Cathy seized him again'
(Chapter 7)
Pen and Indian ink, 30 × 28.5 (11¾ × 11¼)
The Museum of Modern Art, New York,
Collection John S. Newberry, no. 205.63

A study of the characters Nelly Dean, Heathcliff
and Cathy, with two other figures sketched in
and crossed out.

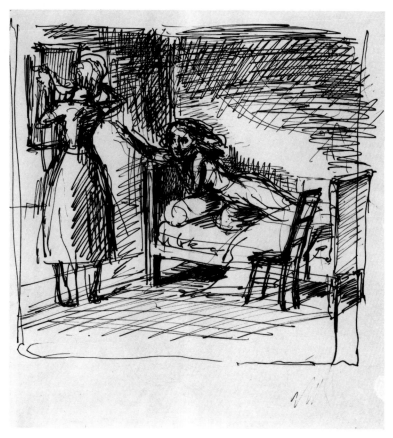

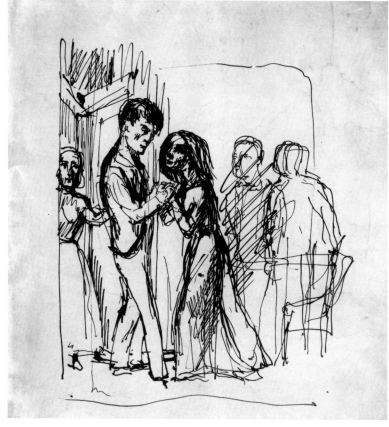

*Related studies for the illustrations
to* Wuthering Heights, *1933
(nos 18–27)*

19 *Cathy and Heathcliff on the Moor*
Pen and Indian ink, 26 × 20.5 (10¼ × 8⅛)
Collection Mrs Richard L. Selle, New York

The same subject as no. 6, with changes in the
background.

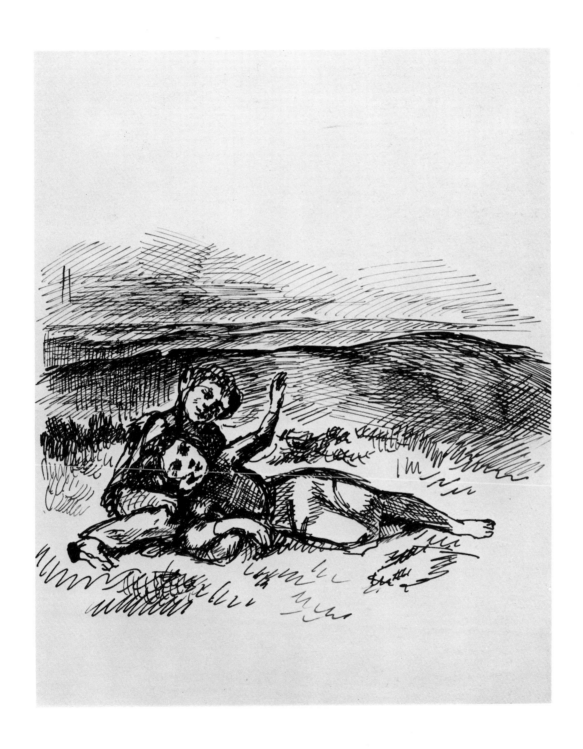

20 a) (recto) *Heathcliff and Cathy*
Pen and Indian ink, 31.5 × 25.5 (12⅜ × 10)
Collection Pierre Matisse, New York

A variant of no. 16.

b) (verso) Study of characters
Pen and ink, 31.5 × 25.5 (12⅜ × 10)
Collection Pierre Matisse, New York

Probably a preliminary study for no. 14.

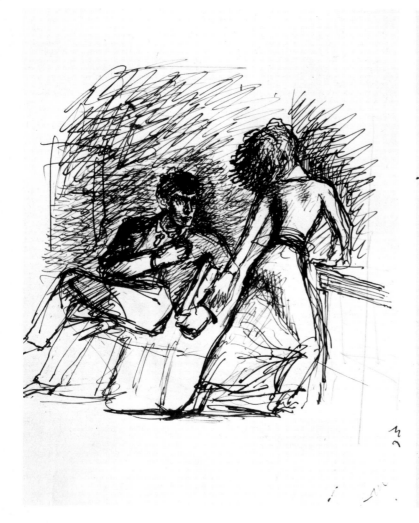

21 *Heathcliff with Cathy Being Bitten by the Dog*
Pen and Indian ink, 21.5 × 17.5 (8½ × 6⅞)
Collection Vicomtesse de Noailles, Fontainebleau

A variant of no. 9

22 'You needn't have touched me'
Pen and Indian ink, 21.5 × 17.5 (8½ × 6⅞)
Collection Vicomtesse de Noailles, Fontainebleau

A variant of no. 11, with different facial
expressions.

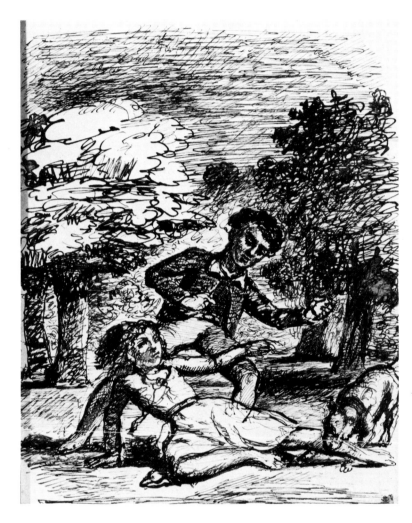

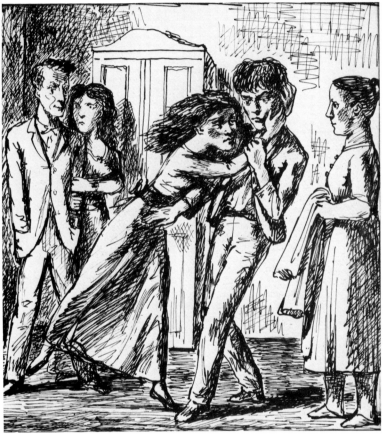

23 '. . . The room is haunted! I'm afraid of being
alone!'
Pen and Indian ink, 21.5 × 17.5 (8½ × 6⅞)
Collection Vicomtesse de Noailles, Fontainebleau

A variant of no. 18a. In this version Nelly is
absent, and solitude accentuates the terror in
Cathy's eyes. (See also no. 26)

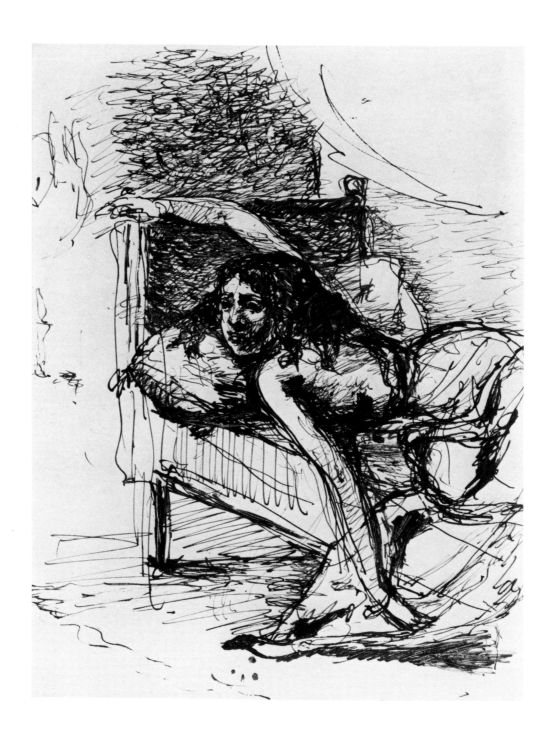

24 *Cathy and Heathcliff Escape from Wuthering
Heights*
Pen and Indian ink, 40 × 31 (15¾ × 12¼)
Collection James H. Kirkman, London

A variant of no. 7

25 'Nelly, did you ever dream queer dreams?'
(Chapter 9)
Pen and Indian ink, 40 × 31 (15¾ × 12¼)
Inscription below in the artist's hand.
Collection James H. Kirkman, London

A variant of no. 14, excluding the wardrobe in the
background. The artist's caption is in fact taken
from an earlier scene in the novel.

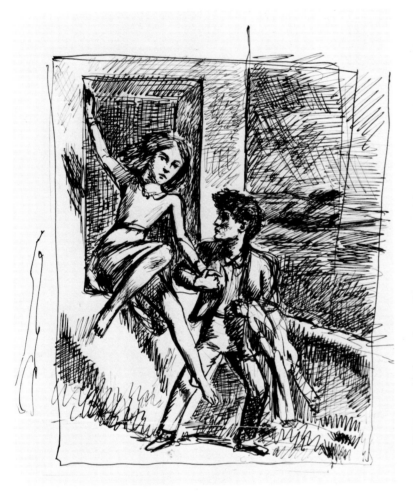

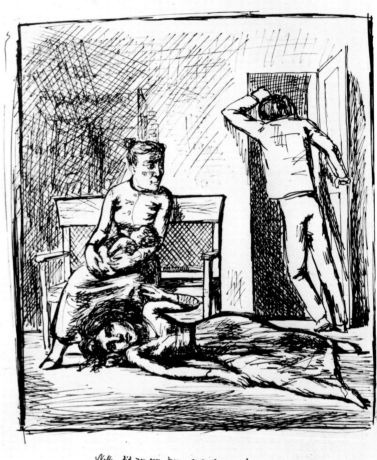

Nelly, did you ever dream queer dreams?

26 'Oh! Nelly, this room is haunted!'
Pen and Indian ink, 40 × 31 (15¾ × 12¼)
Collection James H. Kirkman, London

A variant of 18a, with a different perspective.
The figure of Cathy is very close, both in its
dramatic attitude and its graphic treatment, to
that in no. 23.

27 Study for the painting *Cathy Dressing*, 1933
Pen and Indian ink, 21.5 × 17.4 (8½ × 7⅞)
The Museum of Modern Art, New York, gift of
Mr and Mrs E. V. Thaw, no. 266.64

As pointed out in the introduction, there is a
close connection between this study and no. 12.
(On the verso there is a study for the second
version of *The Street*, 1933–35; for a study for
the first version of that picture, see no. 3.)

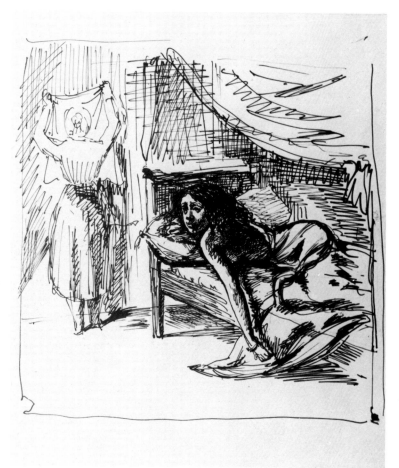

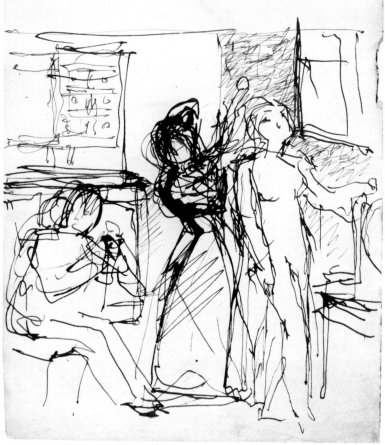

28 *Antonin Artaud*, 1935
Pen and ink, 24 × 20.5 (9½ × 8⅛)
Initialled below right
Collection Pierre Matisse, New York
Repr. Leymarie, 1978

This was drawn on a sheet of paper from the
Dôme café in the Boulevard Montparnasse, Paris.
The café letterhead, on the reverse side, just
shows through in the top right-hand corner. The
drawing was done during rehearsals for *The
Cenci*, the play by Artaud for which Balthus

designed the sets. (See nos 30–32 and the
comments in the Introduction.) The drawing was
published in *La Bête Noire* (no. 2), a review
edited by Tériade and Raynal, together with an
article by Artaud on the project. Artaud, who was
also the author of the *Manifesto of the Theatre of
Cruelty*, shortly afterwards moved to Mexico,
where on 7 June 1936 he had an article published
on the relationship between young French painting
and tradition (see Bibliography, p. 118), a piece
which, as Jean Leymarie has recorded, is still of
extreme relevance to the art of Balthus.

29 *Antonin Artaud*, 1935
Pencil, 30.5 × 23.5 (12 × 9¼)
Initialled and dated bottom right-hand corner,
where Balthus has also written the name 'Artaud'
Private collection, Paris

More fearsome and dramatic than the previous
drawing. Although less clearly defined than no. 28,
it has more expressive force in its look of
hollow-cheeked suffering, and has been set out
almost as though it were a study for a painting
which was never carried out.

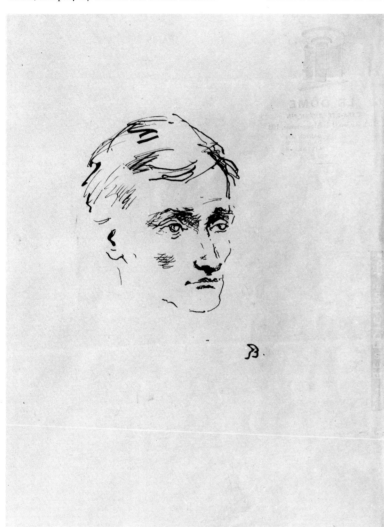

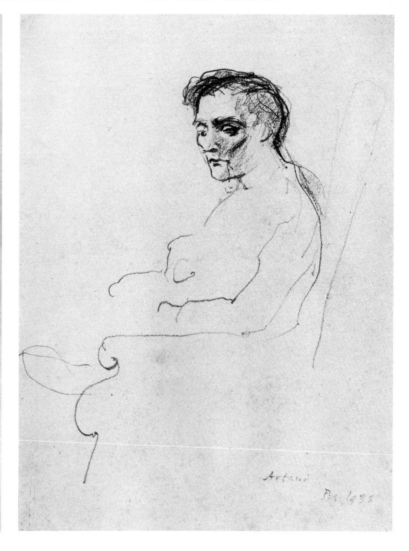

30 Stage design for *The Cenci* by Antonin
Artaud, 1935
Pen and Indian ink, 30.5 × 39 (12 × 15⅜)
Signed and inscribed 'Les Cenci' bottom left
Collection Pierre Matisse, New York

This is one of the studies for the set of *The Cenci*,
which Artaud had based on a subject taken from
Shelley and Stendhal and which was presented at
the Théâtre des Folies Wagram, Paris, in 1935.
(See also the two following illustrations and the
comments in the Introduction.)

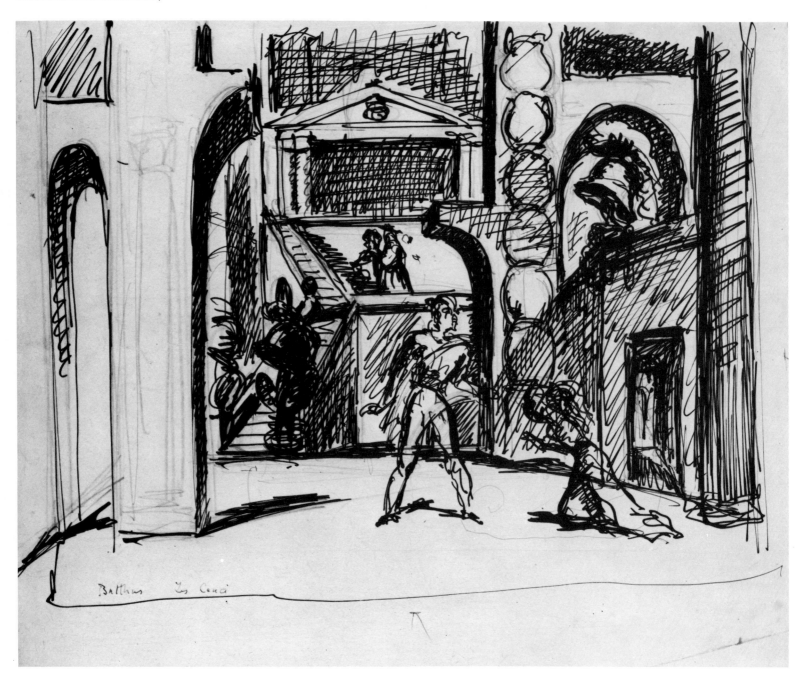

31 Stage design for *The Cenci* by Antonin Artaud,
1935
Graphite and Indian ink, 29.3 × 37 (11½ × 14½)
Signed and dated 1 '35
Allan Frumkin Gallery, New York
Repr. exh. cat. Russell, London 1968 (no. 64);
Sotheby sale cat. 26 March 1980 (no. 245)

A more finished study, which belonged first to
Pierre Loeb and later to the English collector
Barry Miller, London.

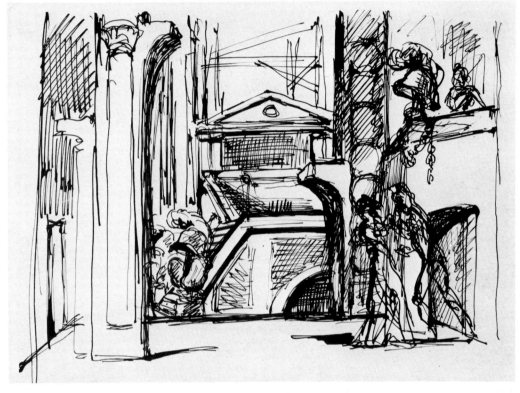

32 Stage design for *The Cenci* by Antonin Artaud,
1935
Graphite and Indian ink, 30 × 37 (11¾ × 14½)
Collection André Berne Joffroy, Paris
Reproduced exh. cat. Berne Joffroy, Paris and
Brussels 1979, p. 33

According to the artist himself, this was the
definitive drawing for the set, which was
constructed on various planes of perspective.

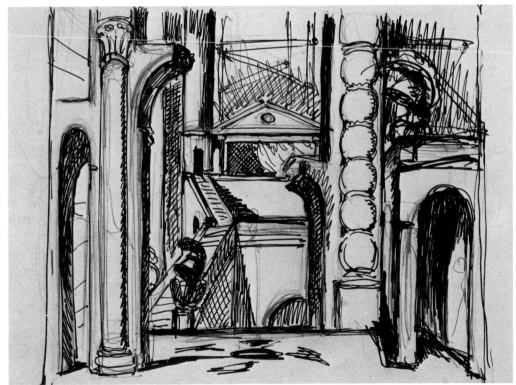

33 *Seated Girl*, c. 1936. Study for *The Children*
(1937)
Pen and ink, 22.5 × 27.5 (8⅞ × 10⅞)
Collection John Rewald, New York
Repr. exh. cat. Rewald, New York 1963 (no. 28);
Russell, London 1968 (no. 86, p. 98)

A preliminary idea for the painting of 1937, which
belonged to Picasso and is now in the Louvre.

In the painting, the girl assumes a completely
different pose, kneeling as she reads a book placed
on the floor, while the boy leans over the table –
the same composition as for drawing no. 5 for
Wuthering Heights. These variations are just a few
examples of the exhaustive preparatory work done
by the artist before he arrived at the final
composition for a painting.

34 *Boy at a Window*, 1936
Pencil, 34.5 × 24.5 (13⅝ × 9⅝)
Initialled bottom right-hand corner
Collection Claude Bernard, Paris

This relates to the previous drawing and is of the
same period. The model was the brother of the
girl depicted there. Both were employed by the
artist as models for *The Children* (1937).

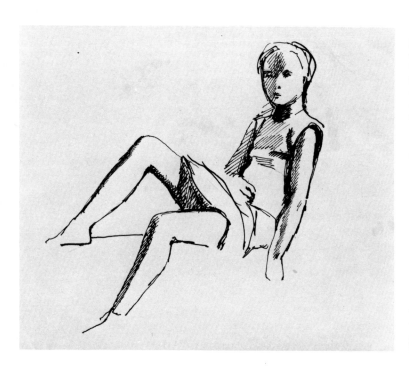

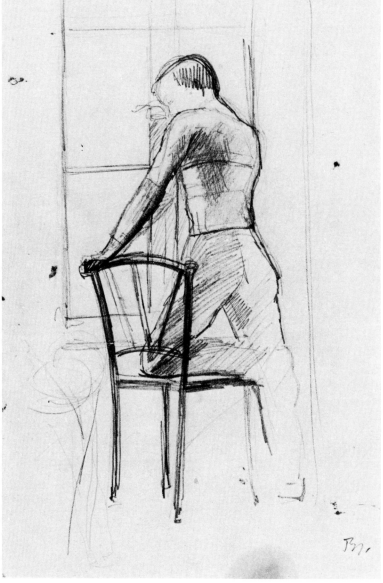

35 *Study of a Tree* (Champrovent), 1939
Pen, ink and wash, 45.6 × 29.5 (18 × 11⅝)
Initialled and dated below, towards the right
Private collection, France

The influence of Far Eastern painting, which first engaged Balthus' interest when, as a boy, he delved into the subject in his father's library, is particularly evident in this drawing. One of the earliest of the artist's landscapes known to us, it has the grace and poetry of a watercolour by a Chinese painter of the Ming dynasty, such as Ch'ên Shun or Hsü Wei. The bond with Oriental art was to be a constant factor in the private and spiritual sphere of Balthus' life and was to recur in his art in the recently completed landscapes of Monte Calvello. From drawings such as this one he may have derived the idea for *The Cherry Tree* (1941).

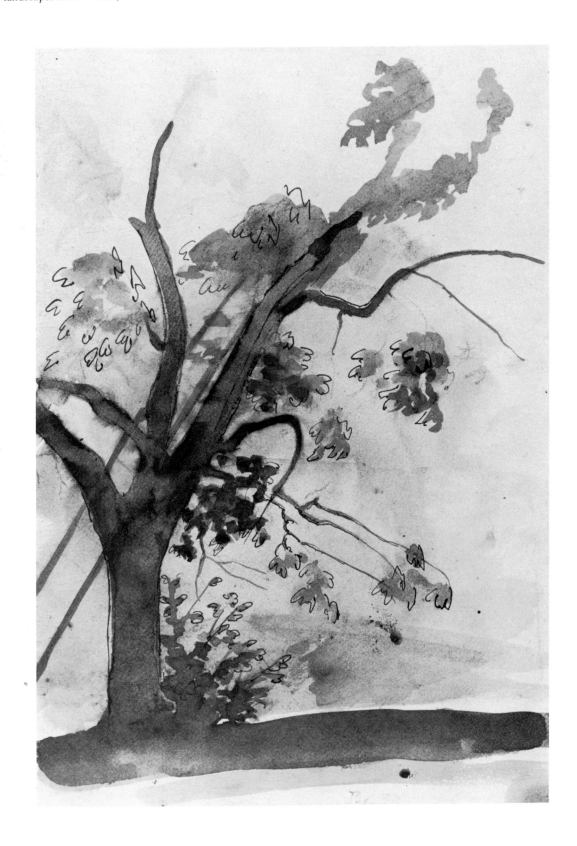

36 *Self-portrait*, 1943
Pencil, 88 × 47.5 (34⅝ × 18¾)
Initialled and dated below, towards the left
Collection Pierre Matisse, New York

See the comments in the Introduction.

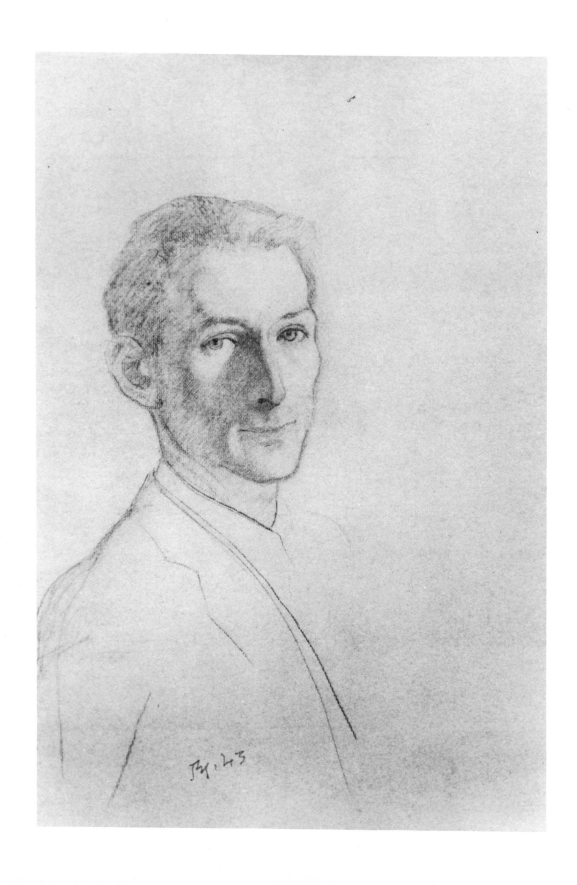

37 *Villa Diodati*, 1946
Pencil and charcoal, 67 × 55 (26⅜ × 21⅝)
Initialled bottom right; on the left, the artist has
written 'Villa Diodati'
Private collection, Paris

This is the villa of a well-known Protestant family
who emigrated from Lucca to Geneva in the
sixteenth century. Balthus stayed in Geneva
towards the end of the war, in the places – as
Jean Leymarie records (1978) – through which
Byron had passed. (He wrote 'The Prisoner of
Chillon' there.) Note the admirable fusion of the
accurately delineated architectural parts and the
sfumato of the trees.

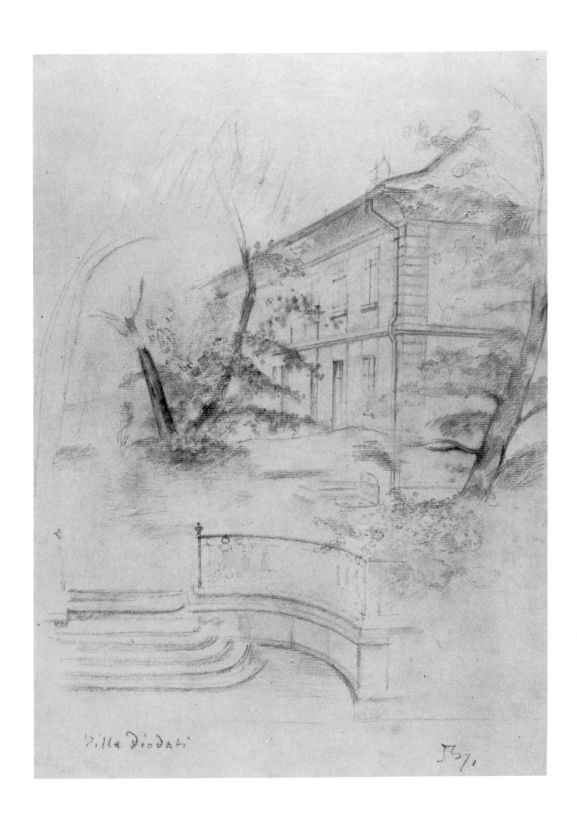

38 *Portrait of A.*, 1943
Pencil, 85 × 77 (33½ × 30¼)
Private collection, Switzerland

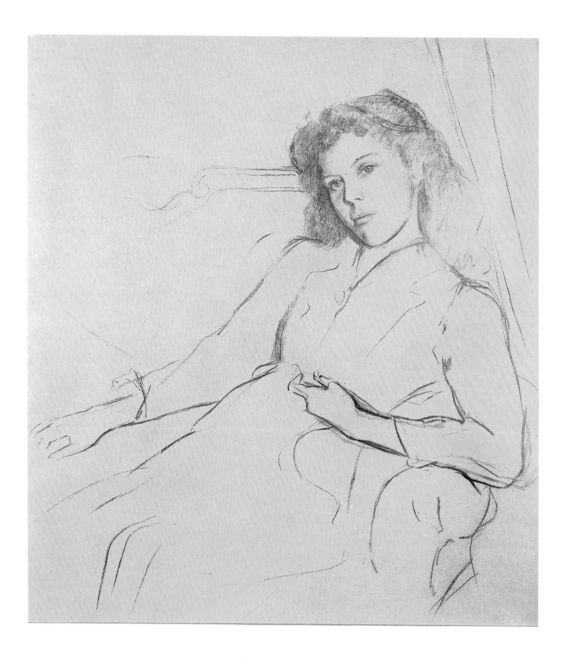

39 *Woman at the Mirror*, 1948
Pastel, 27 × 21 (10⅝ × 8¼)
Private collection, Paris
Repr. exh. cat. Rewald, New York 1963 (no. 26)

In a series of drawings and paintings of this period, Balthus occupied himself with the theme of a young girl's morning toilette. This theme also recurred in other periods, except the most recent. Usually the girl is watched by some enigmatic character.

In the painting *Girl Getting Dressed* of the same year, and in *Georgette Dressing* of 1948–49, the onlooker was somehow a descendant of the house-keeper of *Wuthering Heights*. Here the artist creates even more of an enigma by giving the onlooker a mysterious half-presence.

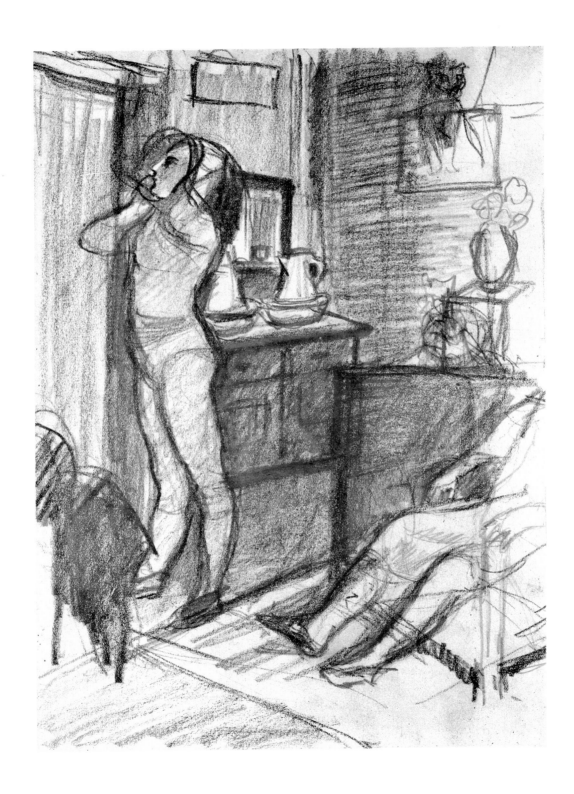

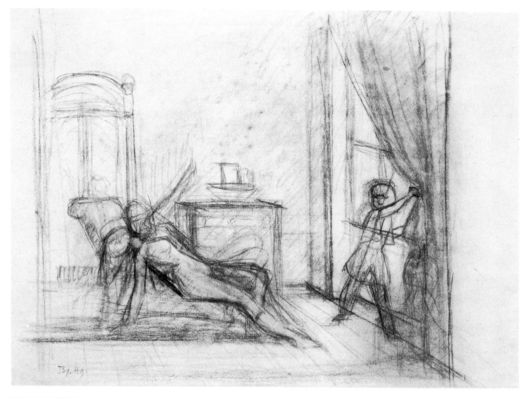

40 Study for *The Room*, 1949
Pencil and charcoal, 38 × 53 (15 × 20⅞)
Initialled and dated bottom left
The Museum of Modern Art, New York,
Collection John S. Newberry, no. 256.78

This is very close to the definitive version of the
large painting of 1952–54 (270 × 335 [106 × 132]),
now in a private collection in Rome (shown at the
Biennale of 1980). The drawing gives two different
positions for the reclining girl and elements of
both are combined in the solution arrived at in
the painting. The only detail missing from the
drawing is the table with the cat. As pointed out
in the Introduction, the ambiguous pageboy
figure who is pulling back the curtain looks as
though it had been based on a distant visual
memory of Sir John Tenniel's Alice.

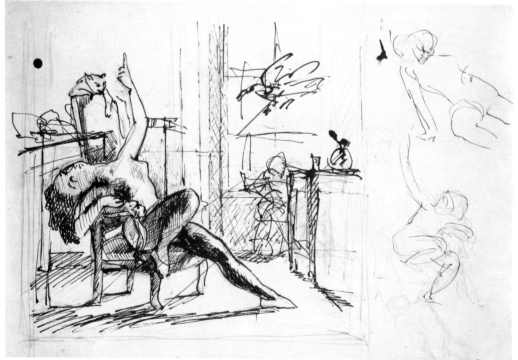

41 Study for the painting *Nude with Cat*, c. 1949
Pen and pencil, 30 × 45 (11¾ × 17¾)
On the right, three sketches of figures
The Museum of Modern Art, New York,
Collection John S. Newberry, no. 377.65

This and nos 42 and 43 are variants of sketches
and studies done for *Nude with Cat* (c. 1954),
now in the National Gallery of Victoria,
Melbourne. It is interesting to note the 'variations
on a theme'.

42 Study for *Nude with Cat*, c. 1949
Pencil, 30 × 40 (11¾ × 15¾)
Initialled lower right
Collection Mme Janine Hao, Paris

The apparition in the background of the strange
figure of the page-boy links the theme of this
composition with that of *The Room* (see no. 40),
and it seems therefore that the artist was trying
out the two contemporaneously and in the end
decided to resolve them in two different paintings.

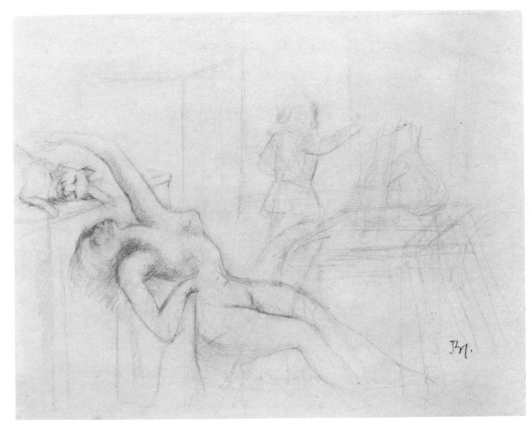

43 Study for *Nude with Cat*, c. 1949
Pen and ink, 29 × 44 (11⅜ × 17⅜)
Collection John Rewald, New York

This is the most thoroughgoing study of the girl's
figure and of the nearby mantlepiece upon which
the cat is playing. In the sketch on the right is the
germ of an idea for the subject of another
painting in which the artist was to depict the
supine figure on its own.

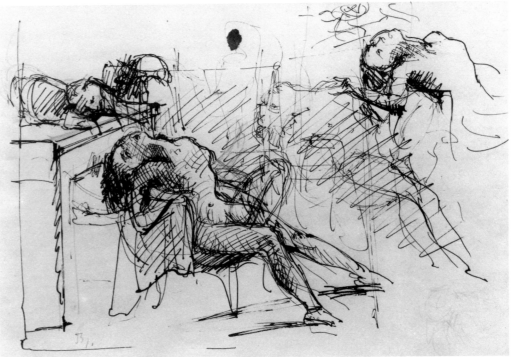

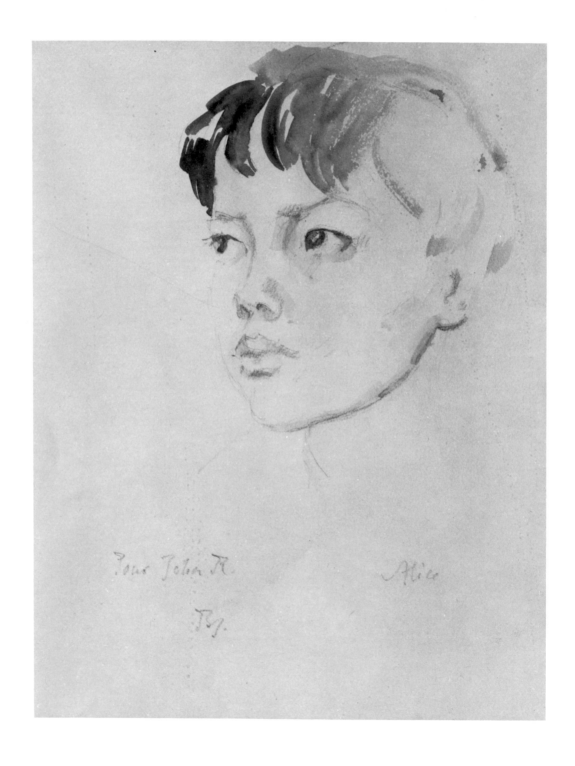

45 *The Guitar Lesson, c.* 1949
Pencil, 29 × 19 (11⅜ × 7½)
Private collection, New York
Repr. exh. cat. Leymarie, Marseilles 1973 (no. 49)

This is not, as one might suppose, a preliminary
idea for the painting of the same name but a
d'après, executed by the artist at least fifteen
years after the completion of the original painting.
The erotic inspiration is the same but the
iconography is substantially altered, since the
painting portrays two women.

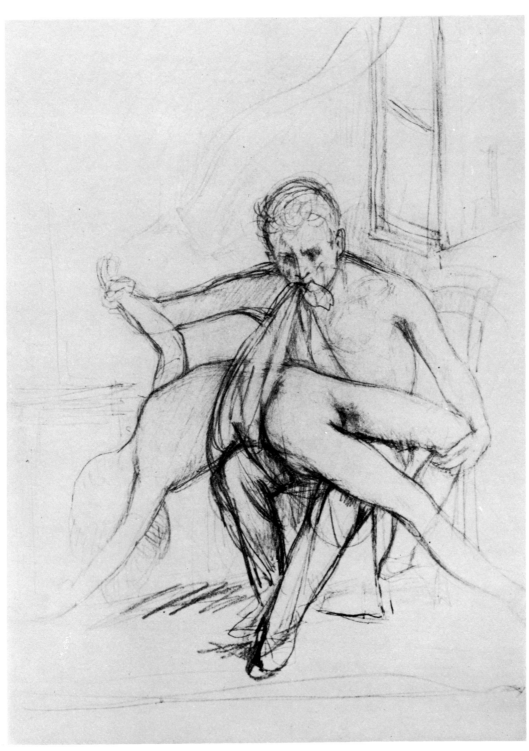

46 Stage design for Mozart's *Così fan tutte*, 1950
Watercolour, 36 × 54 (14⅛ × 21¼)
Galleria Il Gabbiano, Rome

For this watercolour and for no. 48, see the
comments in the Introduction. According to what
the artist has told us, this was the first of several
designs, and there were many variations
incorporated in subsequent sketches which must
still exist, but which we have been unable to trace.

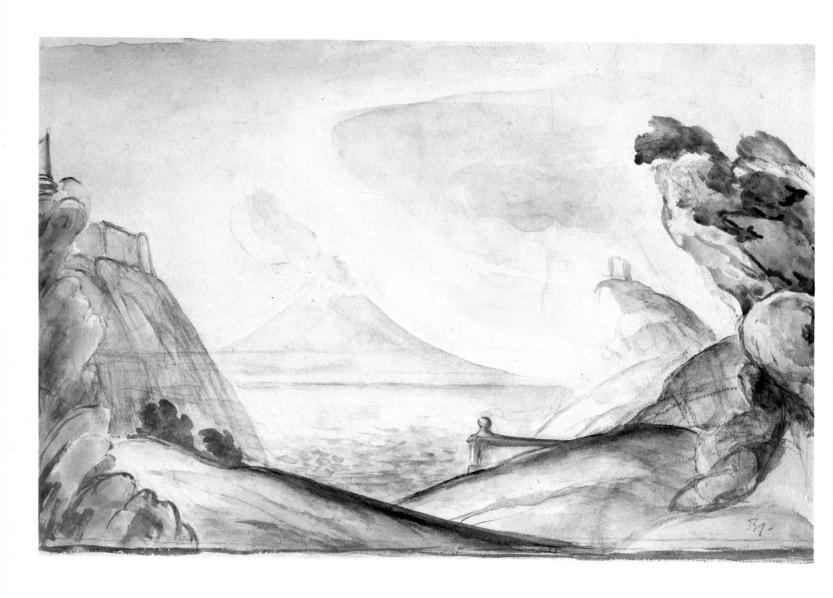

47 *Seated Girl in Profile*. 1950
Pencil and charcoal, 34 × 22 (13⅜ × 8⅝)
Dedicated, signed and dated below
Collection John Rewald, New York

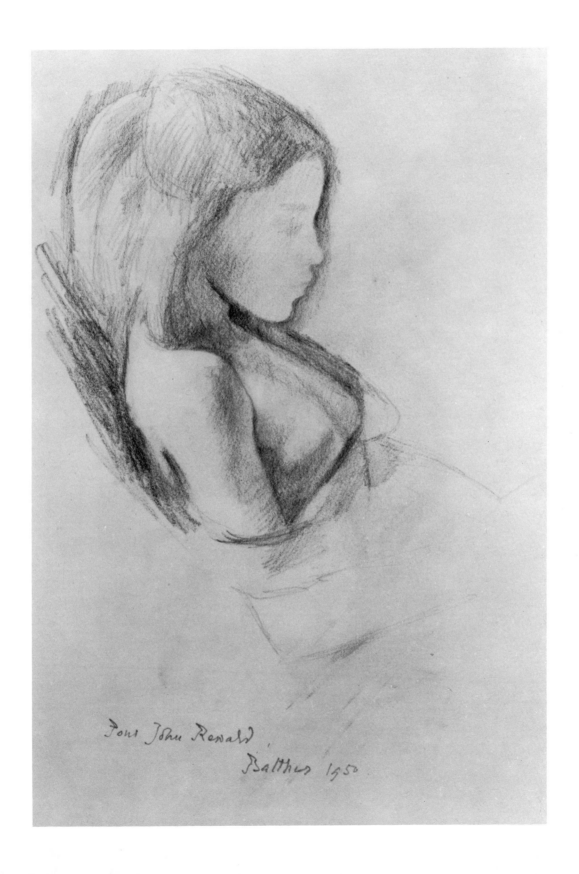

48 Costume for Fiordiligi in *Così fan tutte*, 1950
Watercolour, 23.5 × 28 (9¼ × 11)
Initialled and dated in bottom left-hand corner
Collection John Rewald, New York

As the artist has written in his own hand, this was the first costume design of the series, for Fiordiligi, a role interpreted by the soprano Suzanne Danco at the 1950 celebration of the Festival d'Aix-en-Provence.

 To the right of the figure, the artist has added some notes in French: above, 'silver braid', and below, 'the blue should be a little lighter'. The concern to achieve exactly the right colour, together with the high quality of the draughtsmanship – especially that of the character's head – show the commitment of an artist who was not going to make any compromises in his style while adopting the *métier* of scenographer and costume designer – as should always be so in the theatre. Another costume design for the same production is in a private collection in New York. Both came originally from the Bataille Collection, Paris.

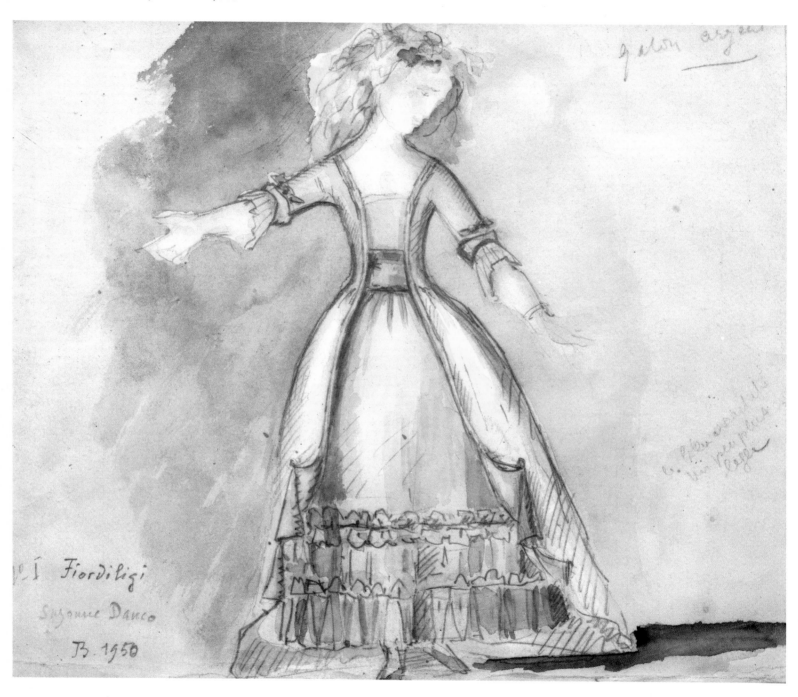

49 *Paysage d'Italie*, 1951
Oil on canvas, 59 × 87 (23¼ × 34¼)
Private collection, Paris

See the comments in the Introduction.

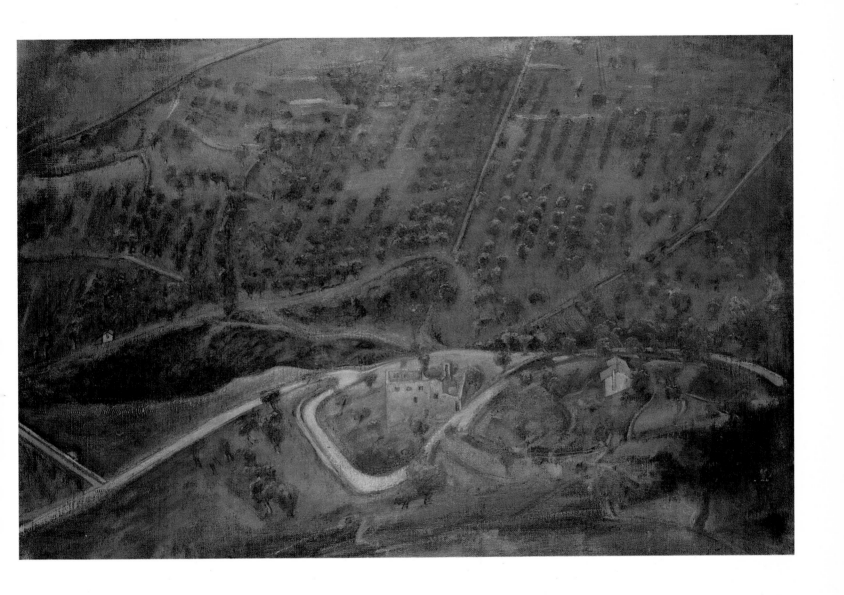

50 Study for *Le passage du Commerce Saint-André*, c. 1952
Charcoal, 37.5 × 54 (14¾ × 21¼)
Initialled below left
Private collection, France

A preliminary idea for the painting (1952–54), but with certain variations. The urban setting is the same but the people are altered, as though the artist drew them from life at different times of the day. The Passage du Commerce Saint-André is a sort of blind alley, opposite the Carrefour de l'Odéon, where the old Paris has been preserved absolutely intact. For those who discover the place after seeing the famous Balthus painting, there is a sense of magic in the way that the reality accords with the artist's metaphysical vision of it.

51 Study for *Le passage du Commerce Saint-André*, c. 1952
Charcoal, 31.2 × 24 (12¼ × 9½)
Initialled bottom right-hand corner
Private collection, France

A sketch for the right-hand side of the final composition. Another drawing (in pencil) of the girl holding a hand up to her chin is reproduced in *Livres illustrés. . . .*, Paris 1982 (no. 248).

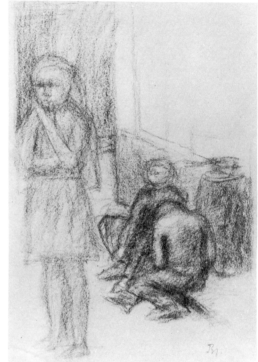

52 *Female Figure and Objects*, 1953
Pencil on squared paper, 29 × 18.5 (11⅜ × 7¼)
Initialled bottom left
Private collection, France

From a notebook of squared paper in which the artist, with a Cézannesque economy of line and solidity of perspective, has sketched scenes from family life in the kitchen at Chassy, the château in the Morvan district where he was living at that time. The drawing is not dated but undoubtedly belongs to the same series as the two which follow. The date is suggested by another version of no. 54, which is marked 1953.

53 *Study of Woman Reading*, 1953
Pencil and charcoal on squared paper,
18.5 × 28 (7½ × 11)
Collection Mrs Richard L. Selle, New York

This has the same Cézannesque quality as the previous drawing and perhaps depicts the same model in another pose.

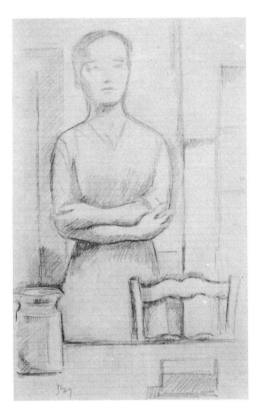

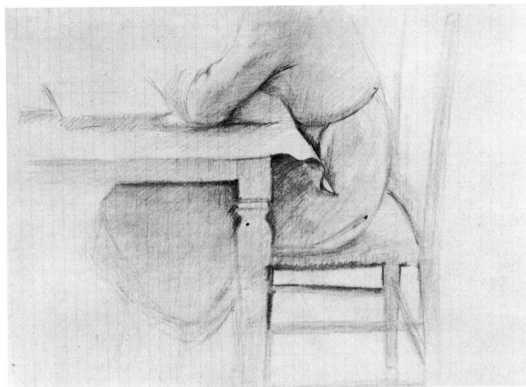

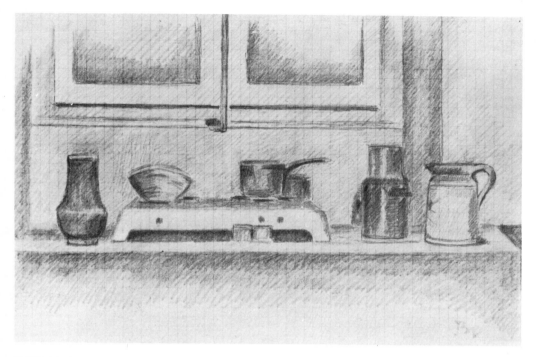

54 *The Kitchen*, 1953
Pencil and charcoal, 18.5 × 28 (7¼ × 11)
Initialled bottom right
Odyssia Gallery, New York

A very similar drawing of the same date, in the
Richard Feigen Collection, New York, portrays
the stove and the same utensils. It was reproduced
in the catalogues of the exhitions at the Galerie
Claude Bernard (Paris 1971, no. 44) and at the
Musée Cantini (Marseilles 1973, no. 50). These
and the two previous drawings undoubtedly
come from the same sketch-book.

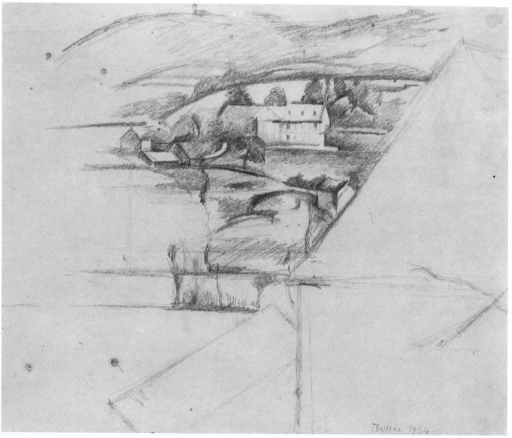

55 *Landscape*, 1954
Pencil and charcoal, 56 × 44.5 (22 × 17½)
Signed and dated below right
Private collection, Paris

See note to no. 56.

56 *Landscape*, 1958
Pencil and charcoal, 53.5 × 41 (21 × 16⅛)
Signed and dated bottom right
Gertrude Stein Gallery, New York
Repr. exh. cat. Leymarie, Paris 1971 (no. 15);
and Szabo, New York 1980 (no. 13)

Both this landscape and the previous one depict
the farmhouse at Chassy. These rustic surround-
ings were a new source of inspiration to the artist.

57 *Landscape* (Chassy), 1955
Pencil and charcoal, 58 × 75 (22⅞ × 29½)
Signed and dated bottom left
Private collection, France
Repr. exh. cat. Leymarie, Paris 1971 (no. 54)

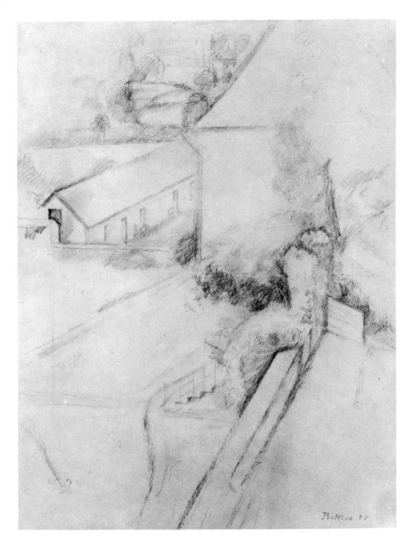

58 a) (recto) Study for the first version of
The Dream, c. 1955
Watercolour, 48.7 × 37.4 (19⅛ × 14¾)

A preparatory study for the left-hand side of
The Dream, with the variation of the window in
the background which was to re-appear in
Golden Afternoon (1957).

b) (verso) Studies of landscapes in the Morvan region
Watercolour, 48.7 × 37.4 (19⅛ × 14¾)
Private collection, Paris

Four landscape studies, with rolling hills and bright, lush vegetation. The top left-hand study has a lightness of touch which is almost oriental.

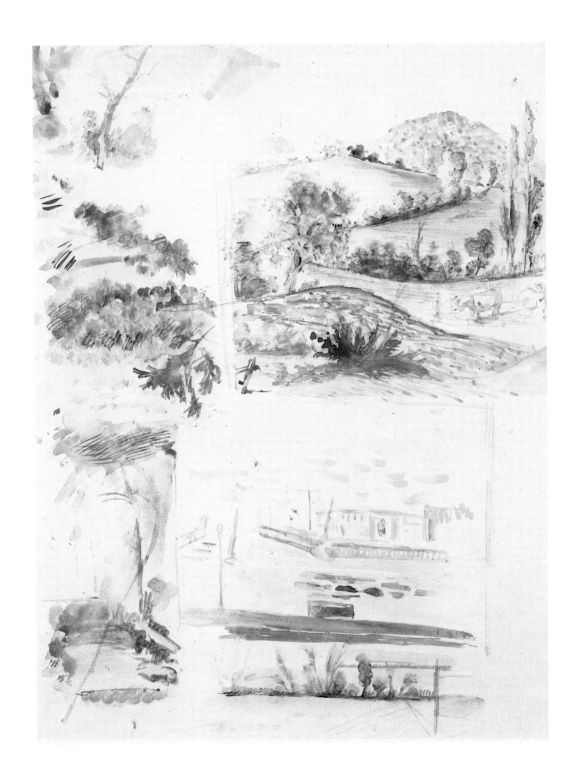

59 Study for the second version of *The Dream*,
c. 1956
Pencil with touches of pastel,
43.8 × 54.6 (17¼ × 21½)
Initialled below left
Collection William R. Acquavella, New York

In comparison with the first version of the
painting, the second has a deeper perspective
towards the background, and this is already
indicated in the drawing by the oriental rug
behind the sofa.

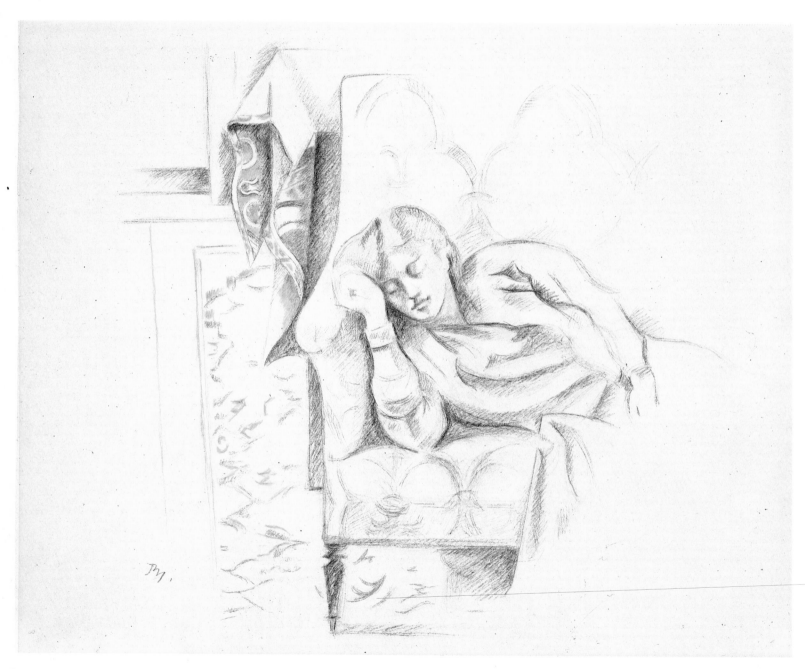

60 Study for the second version of *The Dream*,
1956
Pencil and watercolour, 44 × 56 (17⅜ × 22)
Initialled bottom right
Private collection, Zürich

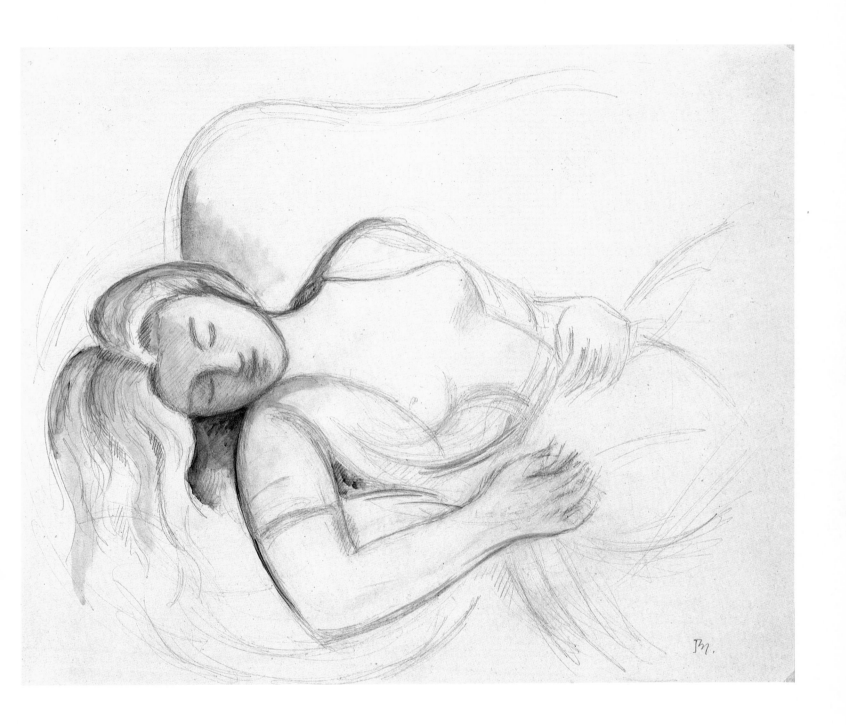

61 *Nude in Front of a Mantle*, 1955
Pencil on squared paper, 29.5 × 19 (11⅝ × 7½)
Initialled bottom left
Galleria dell'Oca, Rome

One of the preparatory studies done for the picture of the same name painted in the same year, now in the Metropolitan Museum, New York. Another very similar study for the same composition appeared at the exhibition held at the Gertrude Stein Gallery, New York, in May–June 1980, and was reproduced on the cover of the catalogue.

62 Study for *La Tireuse de Cartes*, 1955
Pencil and charcoal, 54.5 × 42 (21½ × 16½)
Signed and dated below left
Private collection, Paris

This apparently depicts a young girl playing patience, but she could also be reading the cards (a memory of Caravaggio's *Fortune-teller*).

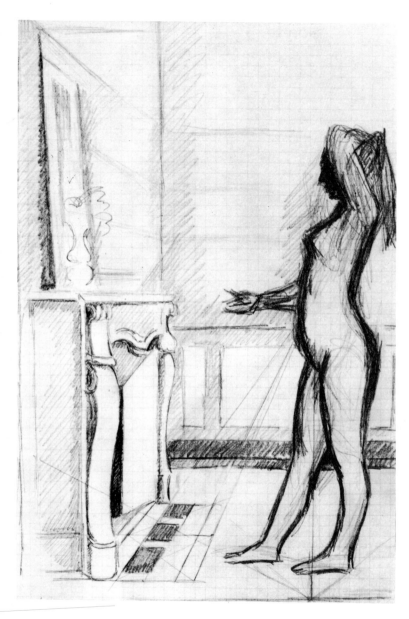

64

63 Study for the painting *La Tireuse de Cartes*,
1955
Pencil with touches of pastel,
54 × 43.5 (21¼ × 17⅛)
Initialled below left
Collection William R. Acquavella, New York

Another, more advanced study of the same motif,
with touches of colour which give an indication
of the eventual painting.

64 *The Valley of the Yonne, c.* 1955
Pencil and watercolour, 22.5 × 29.5 (8⅞ × 11⅝)
Private collection, Chicago
Repr. exh. cat. Rewald, New York 1963 (no. 43)
Bouras, Chicago 1966

A delicate landscape of the Morvan hills with the
uplands in the background. Balthus captures the
lyrical atmosphere with the lightest of touches.
Two years later, the artist completed a painting
of the same subject, with the same title.

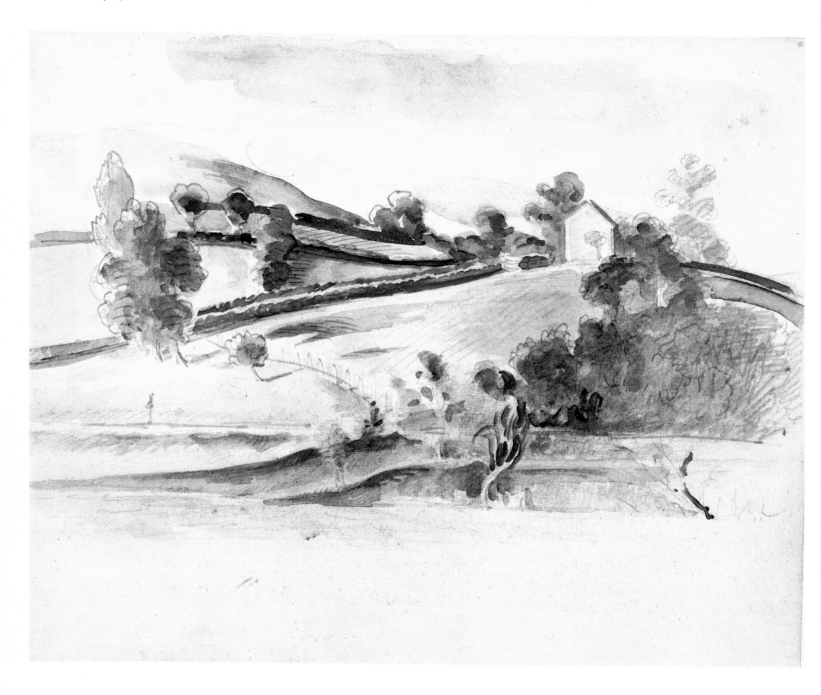

79 *The Grotto*, 1963
Watercolour, 26.5 × 40.7 (10⅜ × 16)
Initialled and dated bottom right
Collection Pierre Berès, Paris
Repr. exh. cat. *Livres illustrés . . .*, Paris 1982
(no. 249).

In the top right-hand corner is a pencil sketch of
a face. On the verso there is a pen-and-ink sketch
for another composition (reproduced in the
catalogue of the exhibition at the Musée Cantini,
Marseilles 1973, no. 63).

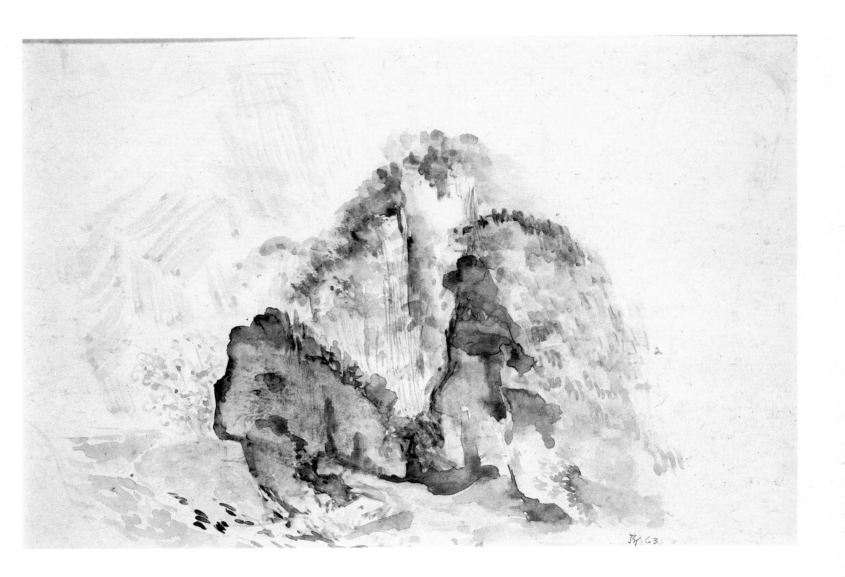

80 *Female Bust*, 1963
Pencil, 56 × 40 (22 × 15¾)
Signed and dated below right
Private collection, New York

This drawing originally carried drawing no. 81
on the verso. By an almost miraculous process,
the restorer has managed to split the paper into
two separate sheets without either drawing
coming to the least harm. The operation was
carried out by an expert at the National Gallery
in London.

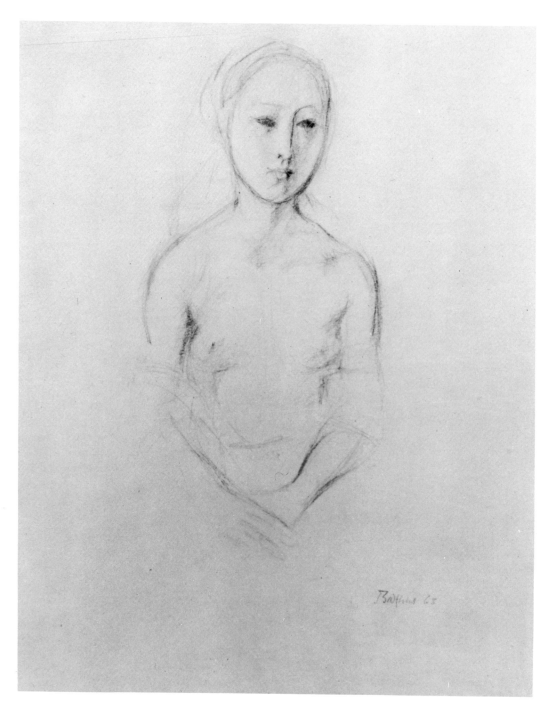

81 *Nude Reposing*, 1963
Pencil, 40 × 56 (15¾ × 22)
Signed and dated bottom left
Private collection, New York

The verso of the previous drawing, separated
from it, together with its paper support.

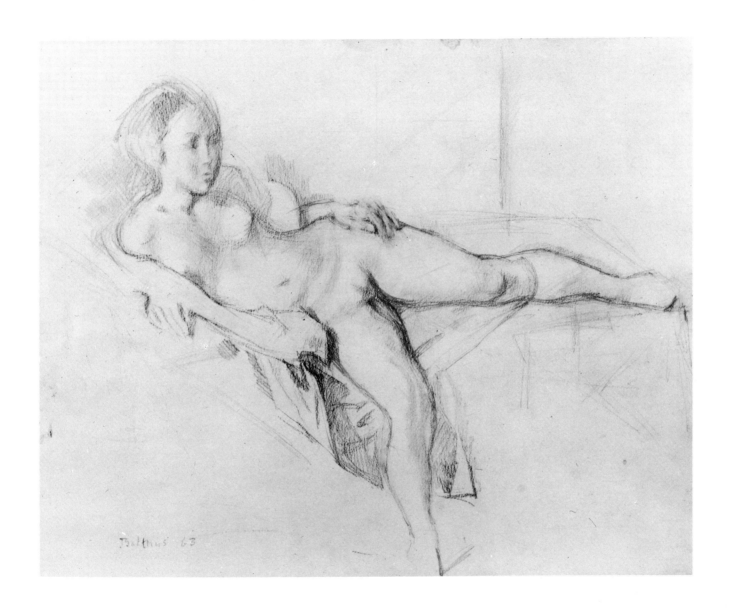

82 *Nude with Beret*, 1963
Pencil and charcoal, 51 × 47 (20⅛ × 18½)
Signed and dated bottom left
Odyssia Gallery, New York; formerly Collection
Joseph H. Hirshhorn

See also no. 106.

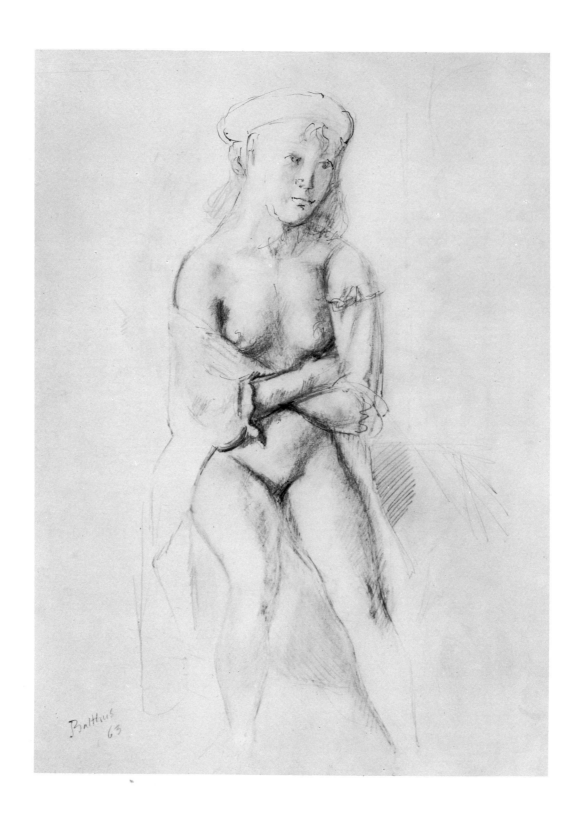

83 *Study of Seated Figure*, 1963
Pencil, 28.5 × 38.5 (11¼ × 15⅛)
Initialled and dated bottom left
Pierre Matisse Gallery, New York

84 *Study of a Sleeping Figure*, 1964
Charcoal, 29 × 23.5 (11⅜ × 9¼)
Initialled and dated bottom left
Pierre Matisse Gallery, New York

Together with the previous illustration, this belongs to a series of quick sketches undoubtedly done in preparation for more finished drawings; a method of setting down instantly certain inspirational ideas, which is the very first phase of the elaborate sequence of events leading to the creation of a Balthus painting.

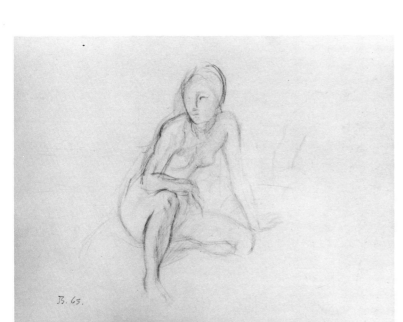

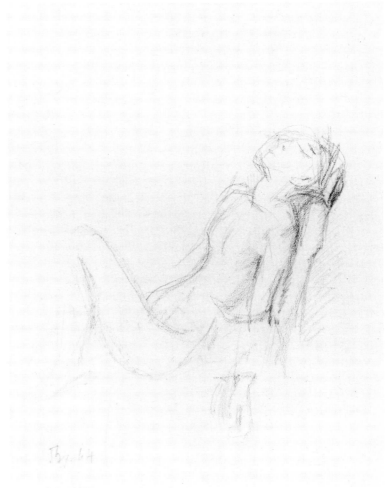

85 *Studies of Figures Copulating*, 1964
Pen and pencil, 38 × 52 (15 × 20½)
Initialled and dated top right with the inscription
'D'après Sukenobu' ('After Sukenobu')
Pierre Matisse Gallery, New York

The Japanese painter Sukenobu (1671–1751) was
also an engraver and an illustrator of everyday
scenes and legendary events. A love of ukiyo-e,
the popular art of the Japanese woodcut, was
implanted in Balthus at an early age and
reinforced when he visited Japan.

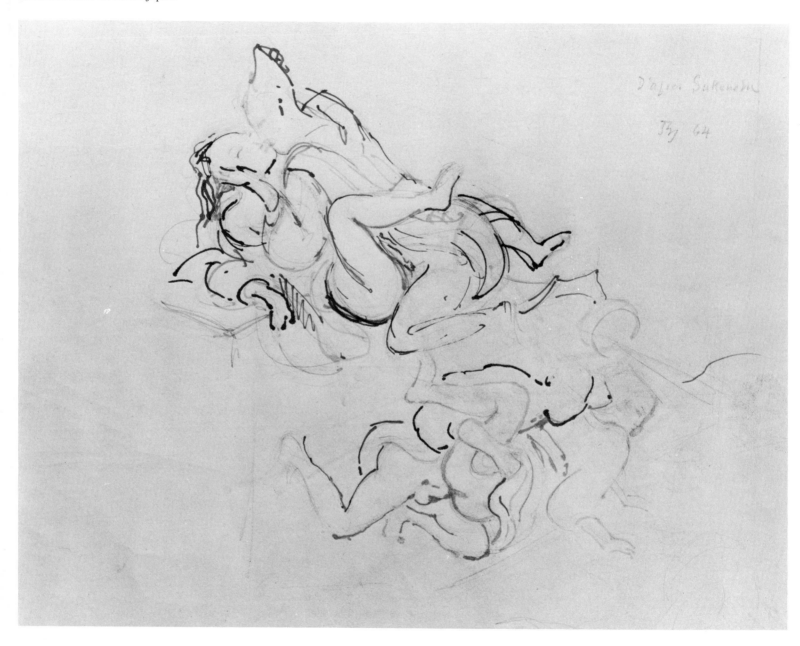

86 *Adolescent Nude*, 1964
Pencil, 38.5 × 28.5 (15⅛ × 11¼)
Signed and dated bottom left
Collection Henriette Gomès, Paris

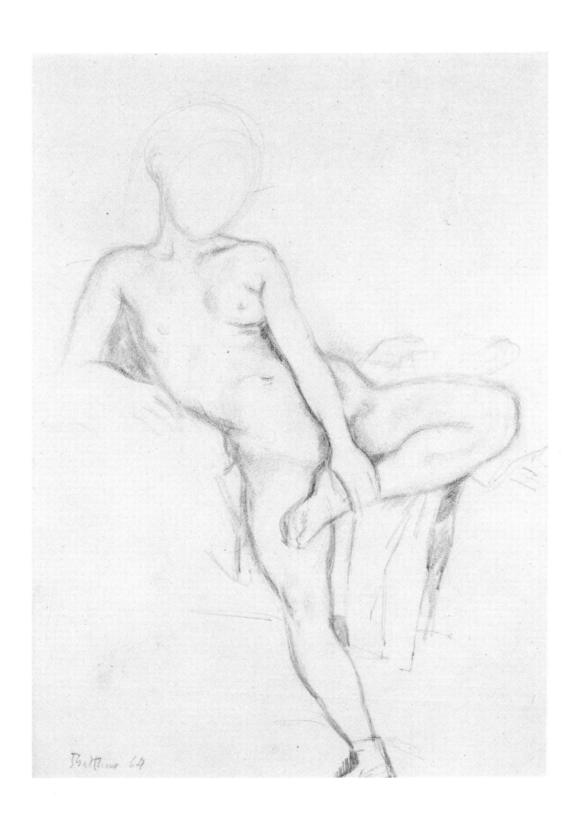

87 *The Amaryllises*, 1964
Watercolour, 32.4 × 31.9 (12¾ × 12½)
Initialled and dated below left
Private collection, France

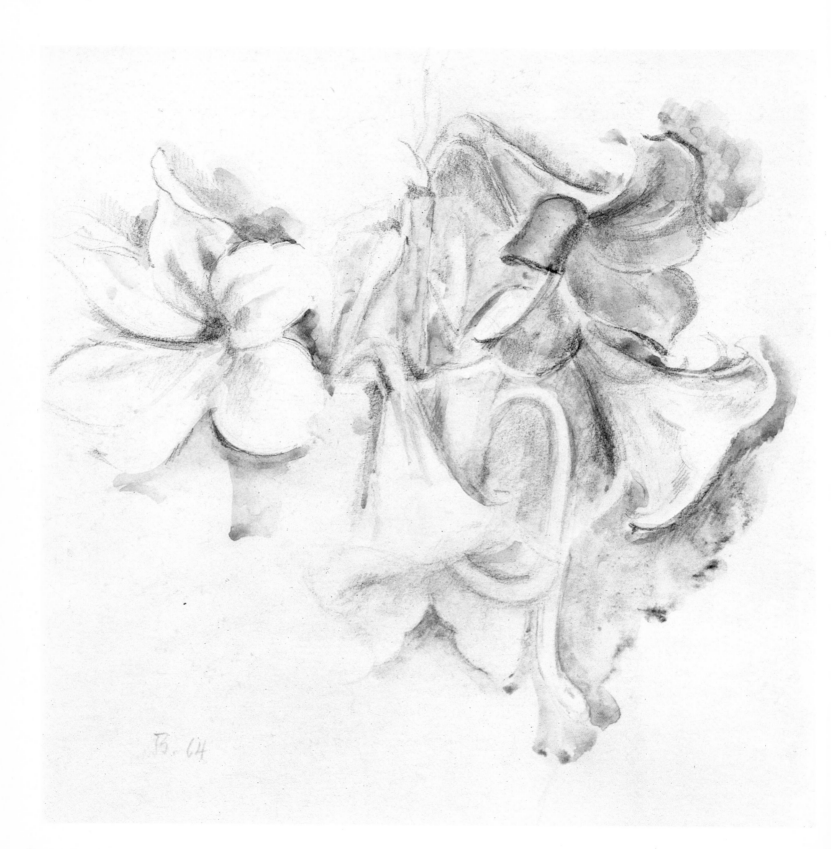

88 *Glass with a Rose*, 1965
Pencil and charcoal on squared paper,
21 × 16 (8¼ × 6¼)
Dedicated bottom left, initialled bottom right
Collection Lorenzo Tornabuoni, Rome

Preparatory study for the watercolour of a vase of
flowers, a pomegranate and an orange (no. 90).
(See also no. 89.)

89 *A Pomegranate*, 1965
Pencil on squared paper, 21 × 16 (8¼ × 6¼)
Dedicated bottom left, initialled on the right
Collection Lorenzo Tornabuoni, Rome

Preparatory study for no. 90

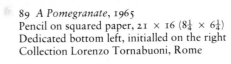

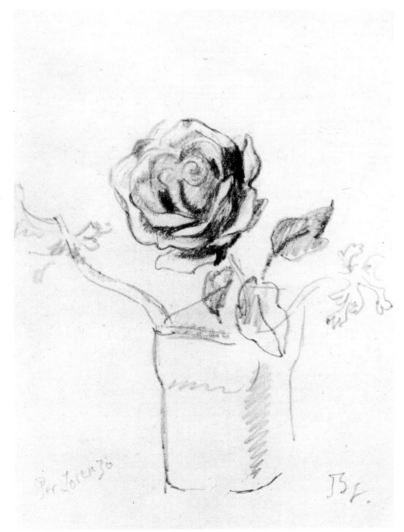

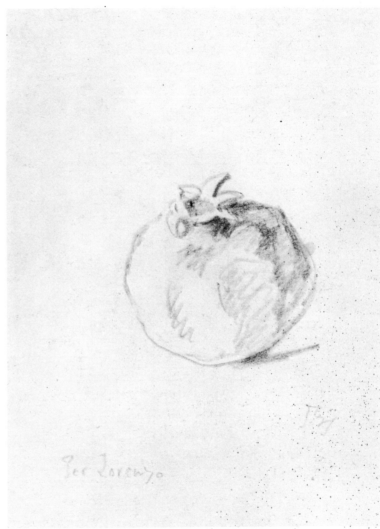

90 *Still-life: Vase of Flowers and Fruit*, 1965
Watercolour, 41 × 48 (16⅛ × 18⅞)
Initialled bottom left with the inscription 'Rome,
janvier 65'
Collection Henriette Gomès, Paris
Repr. exh. cat. Russell, London 1968 (no. 84)

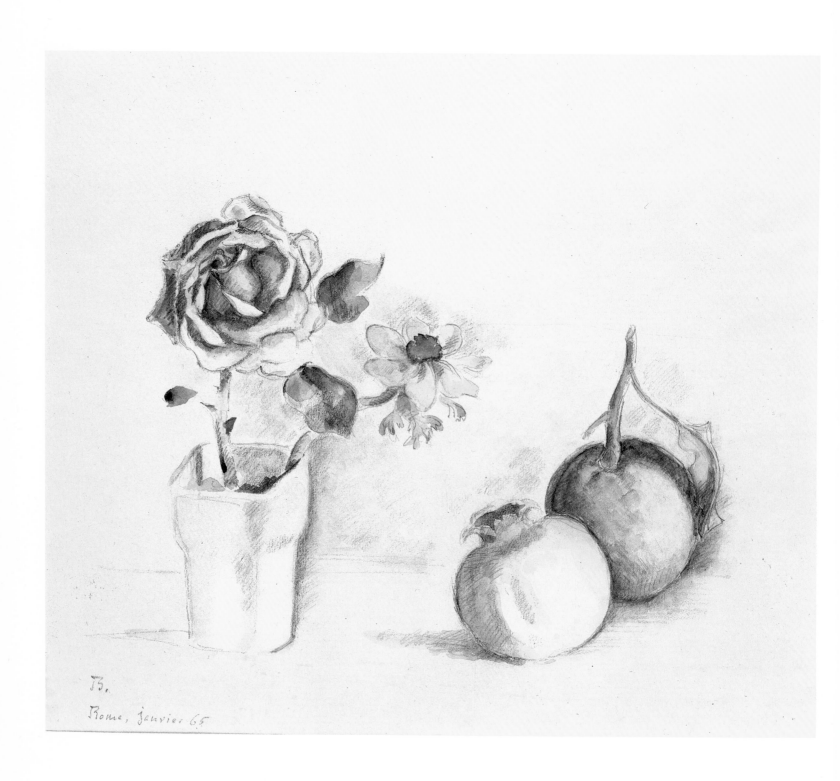

91 *La Japonaise*, 1964
Pencil, 49 × 69 (19¼ × 27⅛)
Initialled and dated below, towards the left
Private collection, Paris

Study for the painting *Japonaise à la table rouge*
(1967–76) (Leymarie, 1978, no. 45).

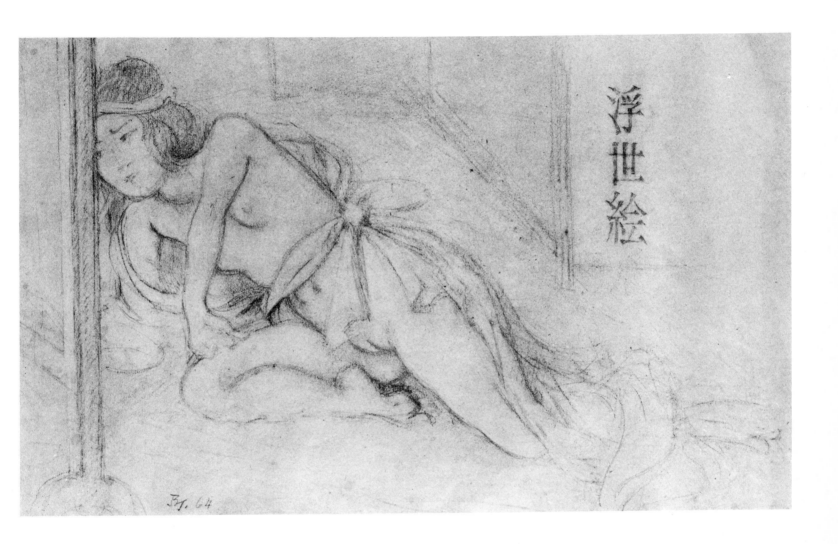

92 *Katia*, c. 1968
Pencil, 23.5 × 28.5 (9¼ × 11¼)
Signed bottom right
Private collection, Rome

93 *Portrait of Katia*, 1969
Pencil, 29 × 23.5 (11⅜ × 9¼)
Dedicated, signed and dated bottom right
Private collection, Rome

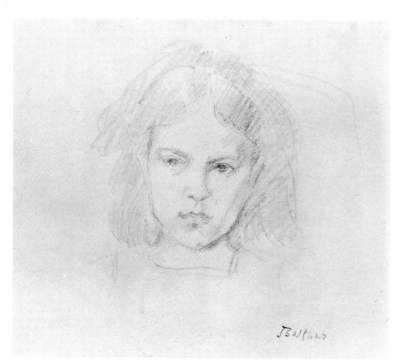

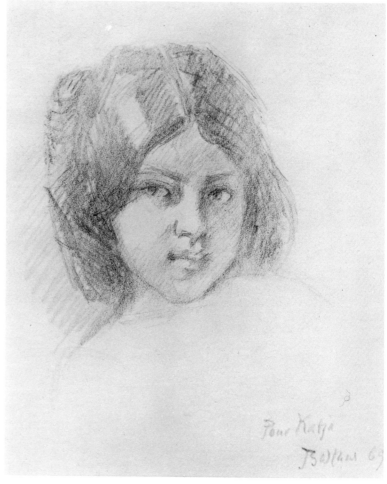

94 *Girl Asleep*, 1969
Pencil and charcoal, 70 × 50 (27½ × 19⅝)
Initialled below, towards the right
Collection Jan Krugier, Geneva
Repr. exh. cat. Leymarie, Paris 1971 (no. 2)

The first drawing in this exhibition to portray
what was to be one of the most frequently
recurring motifs in Balthus' art during the 1970s.

95 *Young Female Nude*, *c.* 1969
Pencil, 67 × 46 (26⅛ × 18⅛)
Signed bottom right
Collection Dr Hubert de Watteville, Geneva

A study for *Sleeping Nude* (1980, reproduced in
the catalogue of the 1980 Venice Biennale, nos
54–56). Another, more recent, variant of the same
theme occurs in no. 132.

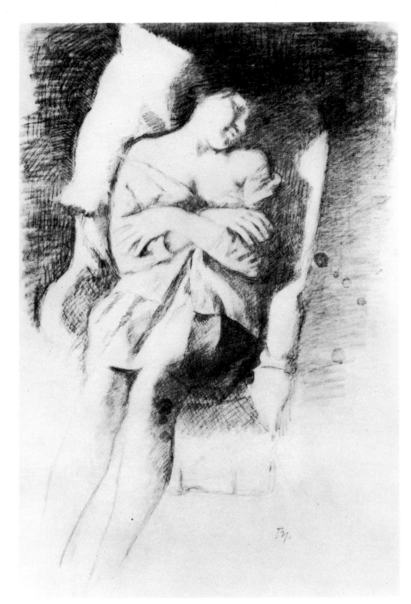

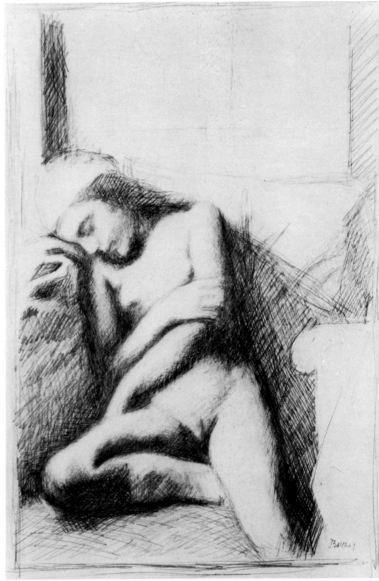

96 Study for *Katia Reading, c.* 1968
Pencil, 26 × 30 (10¼ × 11¾)
Initialled bottom right
Private collection, Turin

One of many studies for the painting *Katia
Reading* (1968–76) (reproduced in Leymarie, 1978,
pl. 43).

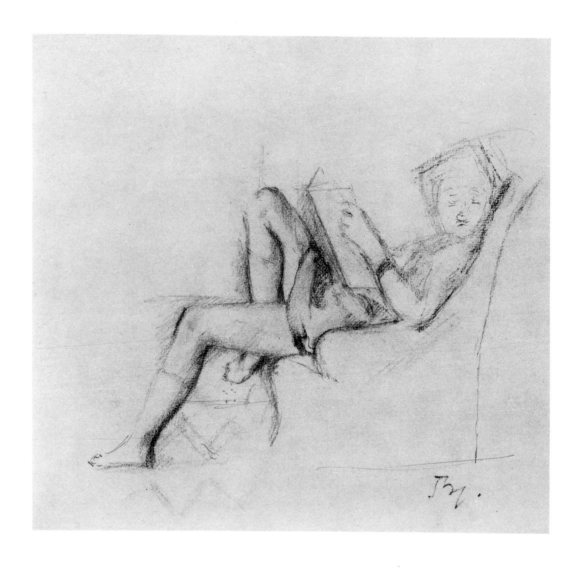

97 *Flowers, Pomegranates and Artichokes, c.* 1970
Watercolour, 50 × 70 (19⅝ × 27½)
Initialled below centre
Claude Bernard Inc., New York
Repr. exh. cat. Leymarie, Paris 1971 (no. 22)

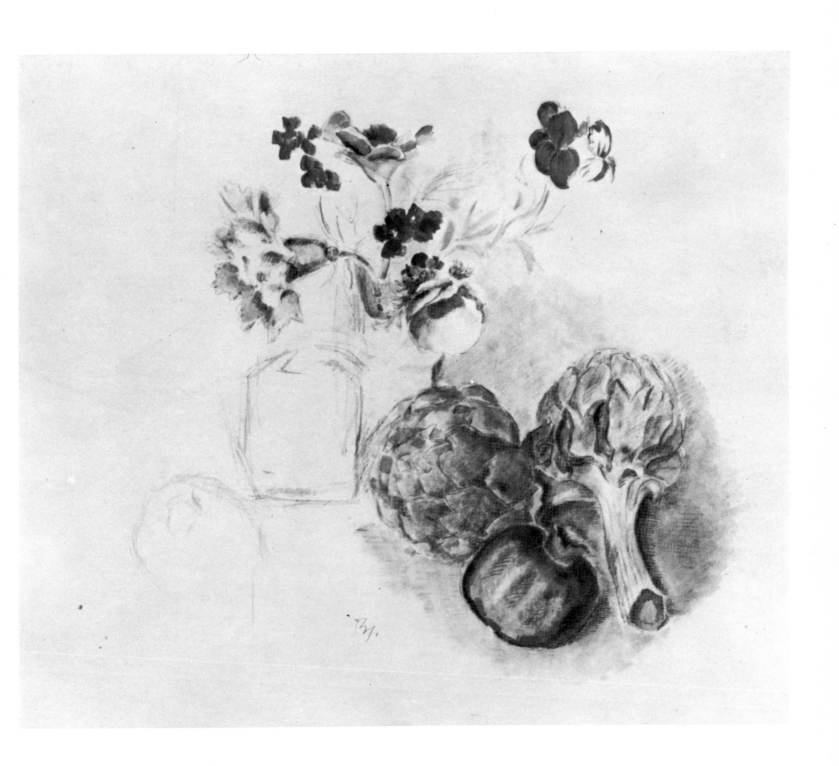

98 *Seated Girl*, 1972
Pencil, 100 × 70 (39⅜ × 27½)
Initialled and dedicated below left
Collection Pierre Matisse, New York

Definitive study for *Nude in Repose* (1977,
reproduced in Leymarie, 1978, no. 47), a painting
of which there are other variants, one being in
the collection of Lorenzo Tornabuoni, Rome.

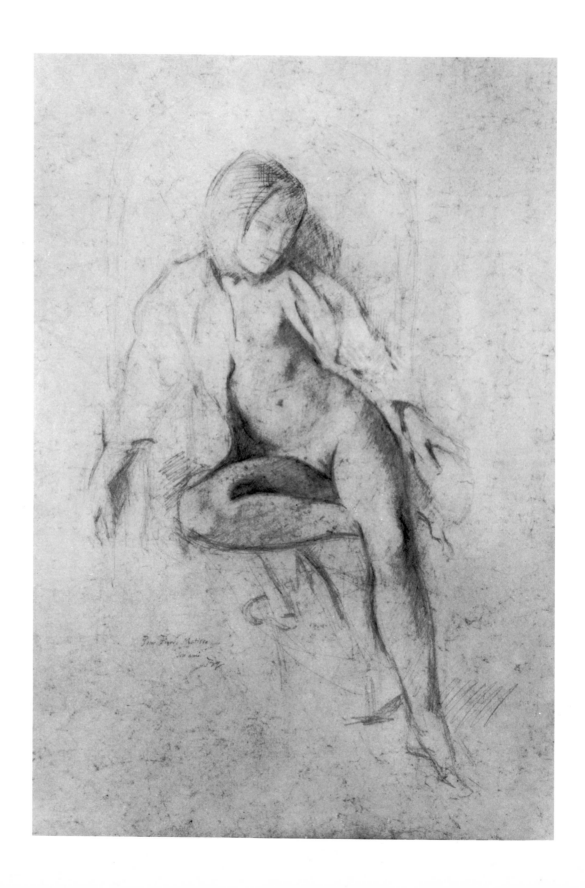

99 *Girl's Head* (Michelina), *c.* 1972
Pencil, 58 × 53 (22⅞ × 20⅞)
Signed below right
Collection Dr Hubert de Watteville, Geneva

100 *Girl Asleep, c.* 1972
Pencil, charcoal and wash, 48 × 33 (18⅞ × 13)
Initialled and dedicated below left
Collection Dino Trappetti, Rome

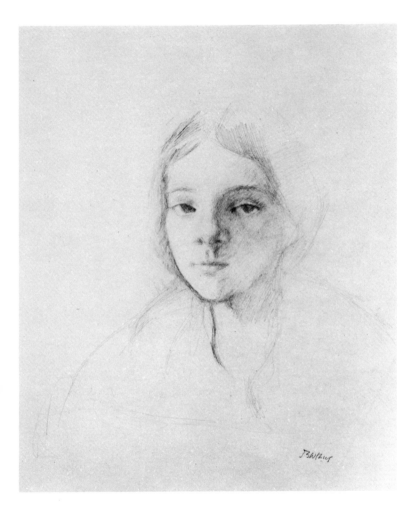

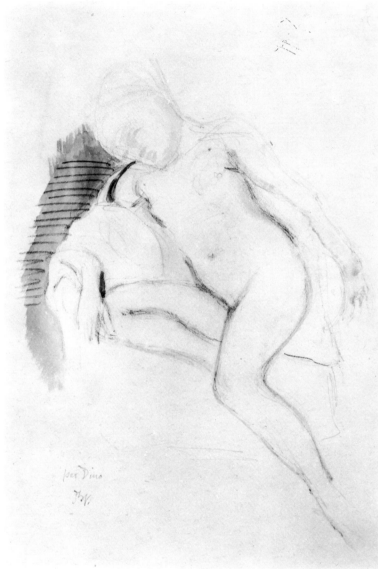

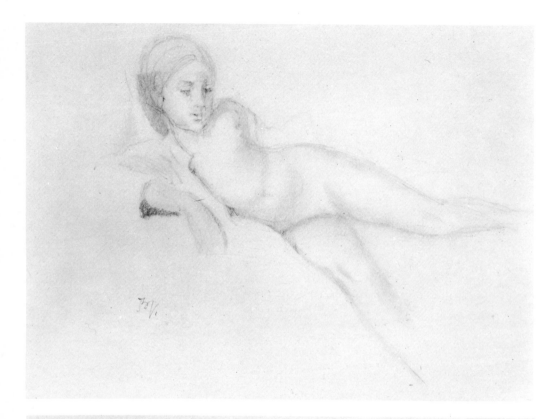

101 *Girl Reclining*, c. 1972
Pencil on ivory-coloured paper,
33 × 48 (13 × 17⅞)
Initialled below left
Collection Dino Trappetti, Rome

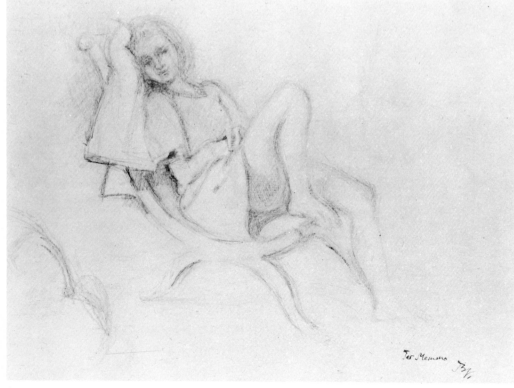

102 *Girl Seated on Chair*, c. 1972–73
Pencil, 34 × 48 (13⅜ × 18⅞)
Initialled and dedicated bottom right
Collection Memmo Mancini, Rome

103 *Michelina I*, 1973
Pencil and charcoal, 100 × 70 (39⅜ × 27½)
Initialled and dedicated bottom left
Collection Piero Bigongiari, Florence

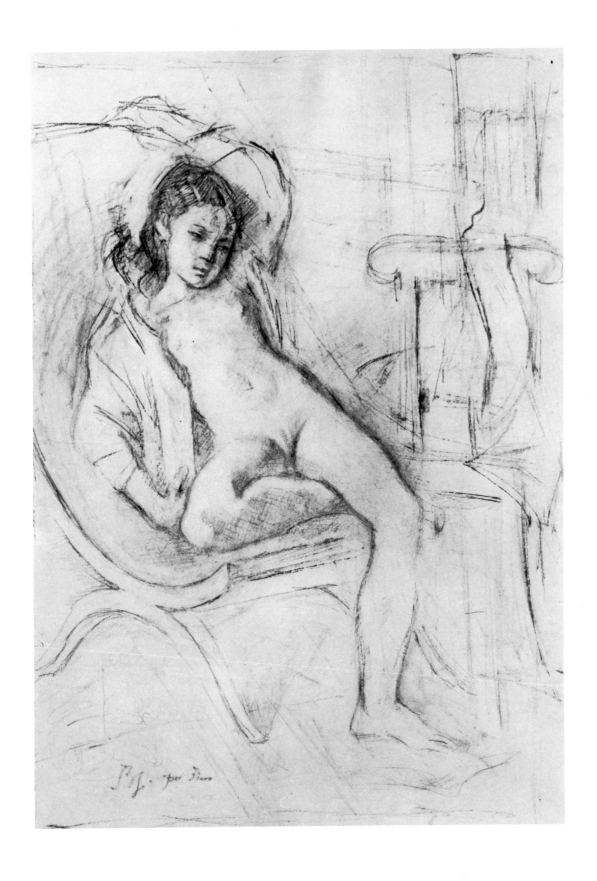

104 *Michelina II*, 1973
Pencil, 40 × 30 (15¾ × 11¾)
Initialled below, towards the right
Collection Piero Bigongiari, Florence

105 *Michelina III*, 1973
Pencil, 40 × 30 (15¾ × 11¾)
Initialled bottom right
Collection Piero Bigongiari, Florence

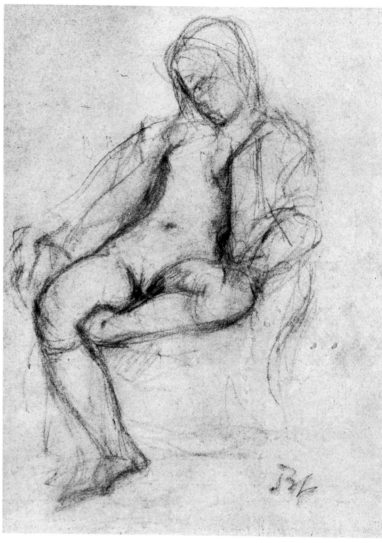

106 *Bust of Girl, c.* 1972
Pencil on yellowy Elephanthide paper,
48 × 32 (18⅞ × 12⅝)
Initialled and dedicated bottom left
Collection Umberto Tirelli, Rome

A repeat of no. 82, both in the model's pose and
her clothing.

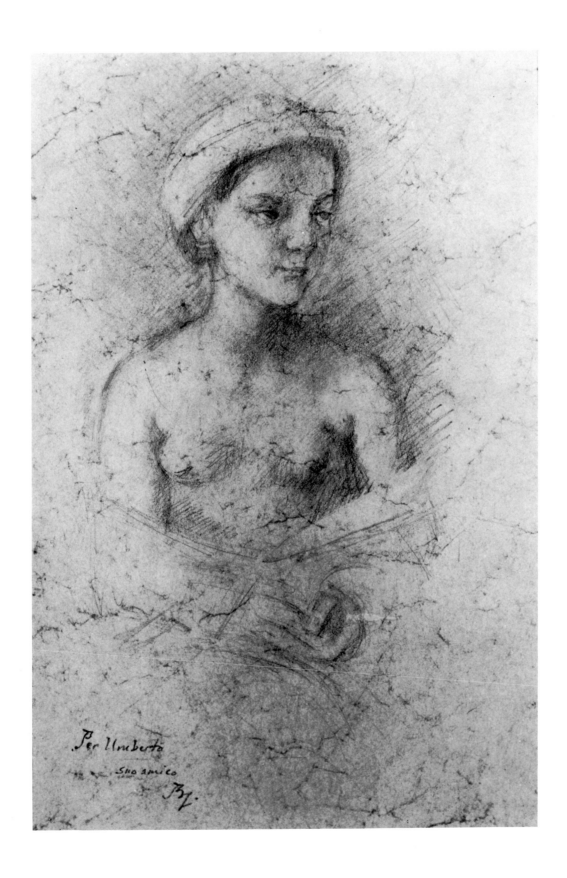

107 *Portrait of Michelina, c.* 1973
Pencil, 67 × 70 (26⅜ × 27½)
Initialled below right
Private collection, Rome

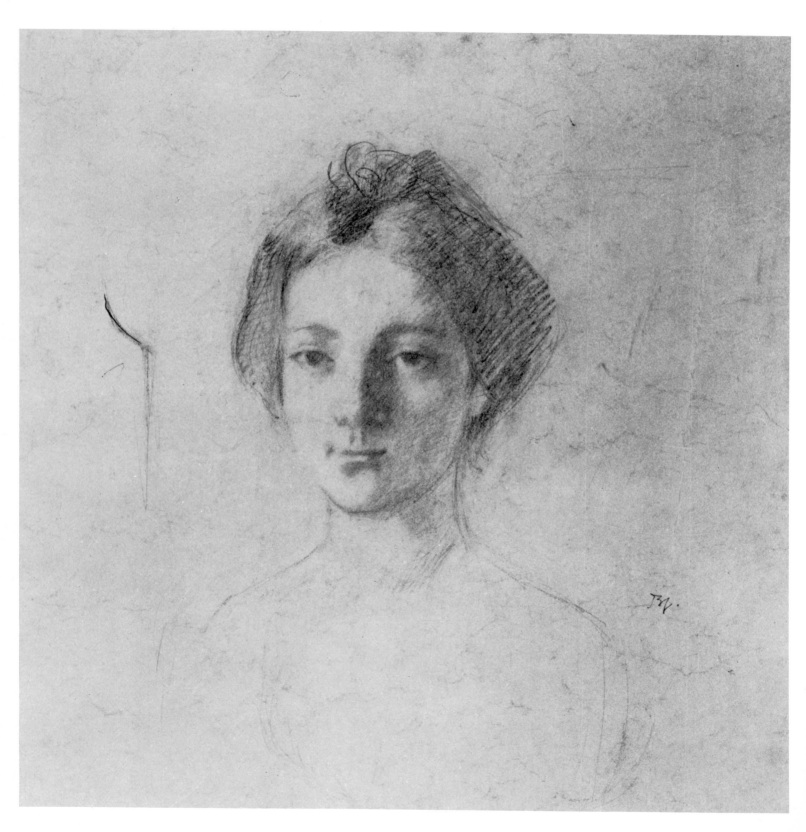

108 *Two Roses, c.* 1974
Pencil and charcoal, 39 × 56 (15⅜ × 22)
Initialled and dedicated, in Japanese, below centre
Collection Countess Klossowski de Rola

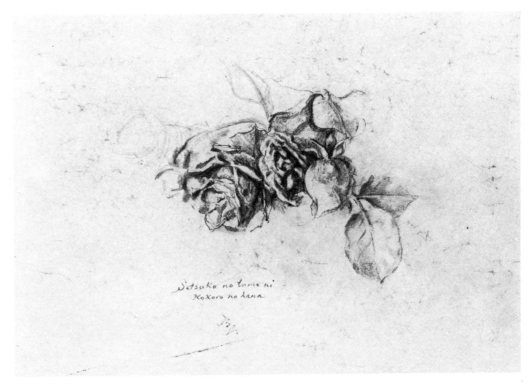

109 *Figure Study,* 1974
Pencil, 57 × 70.3 (22½ × 27⅝)
Initialled and dedicated bottom left
Collection Memmo Mancini, Rome

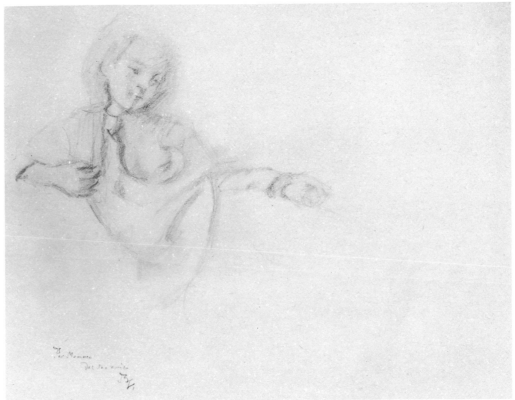

110 *Portrait of Michelina*, 1975
Pencil, 29 × 26 (11⅜ × 10¼)
Signed, dedicated and dated 'Natale 1975'
('Christmas 1975') in bottom right-hand corner
Private collection, Rome

111 *Katia*, 1975
Pencil and charcoal, 54 × 47 (21¼ × 18½)
Signed bottom right. Dedicated and dated 'pour
Noël 1975' ('for Christmas 1975') bottom left
Galerie Jan Krugier, Geneva
Repr. exh. cat. *Grands maîtres contemporains*,
Monte-Carlo 1979–80 (no. 1).

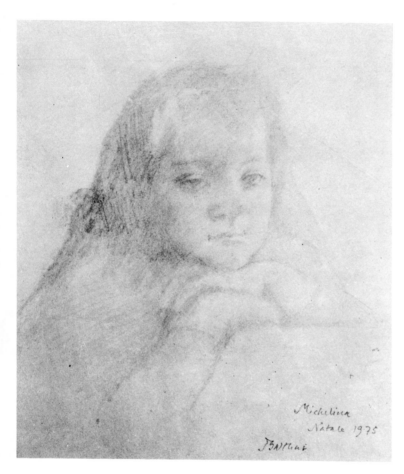

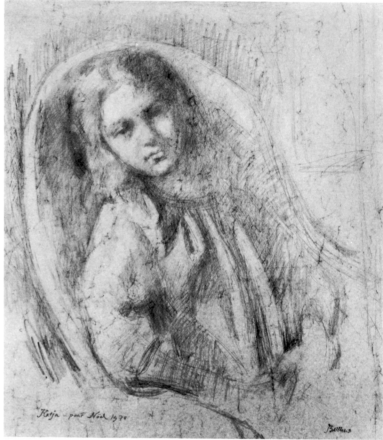

112 *Nude in a Room*, c. 1975
Pencil and charcoal, 36 × 35.5 (14⅛ × 14)
Initialled bottom left
Galleria Il Gabbiano, Rome

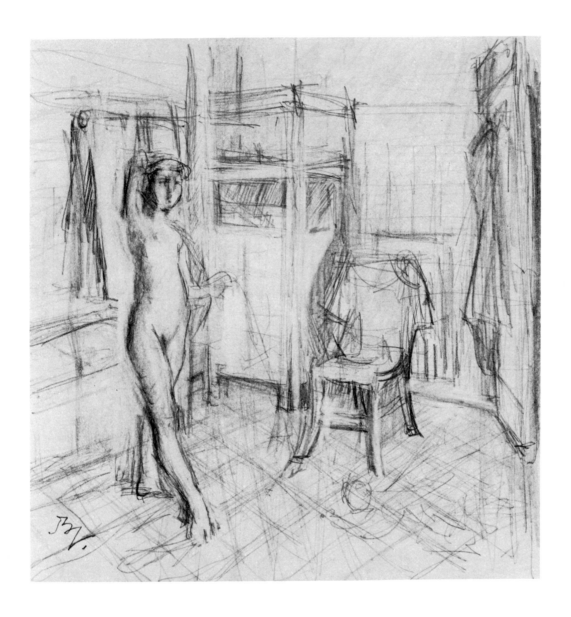

113 *Girl Kneeling, her Arms on a Chair*, c. 1976
Pencil, 70 × 100 (27½ × 39⅜)
Odyssia Gallery, New York
Repr. Leymarie, 1978 (pl. XII)

This is one of the preparatory drawings for
The Painter and His Model (1981–82), now in the
Pompidou Centre, Paris.

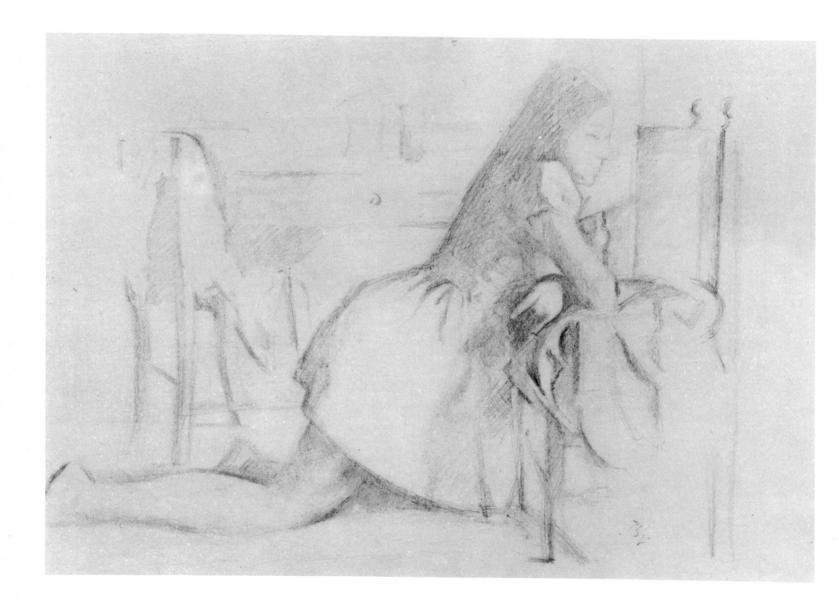

114 *Michelina*, 1976
Pencil and charcoal, 34 × 38 (13⅜ × 15)
Initialled and dated '14 VI 1976' above right;
further down there is a quotation from Lewis
Carroll (the last six lines from his prefatory poem
for *Through the Looking-glass*)
Private collection, Rome

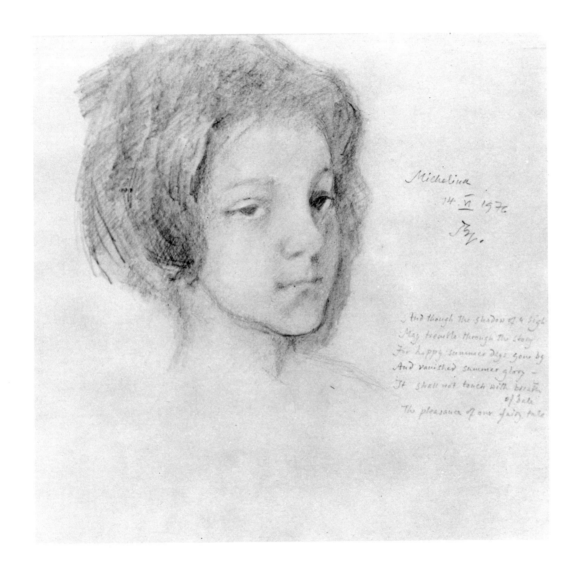

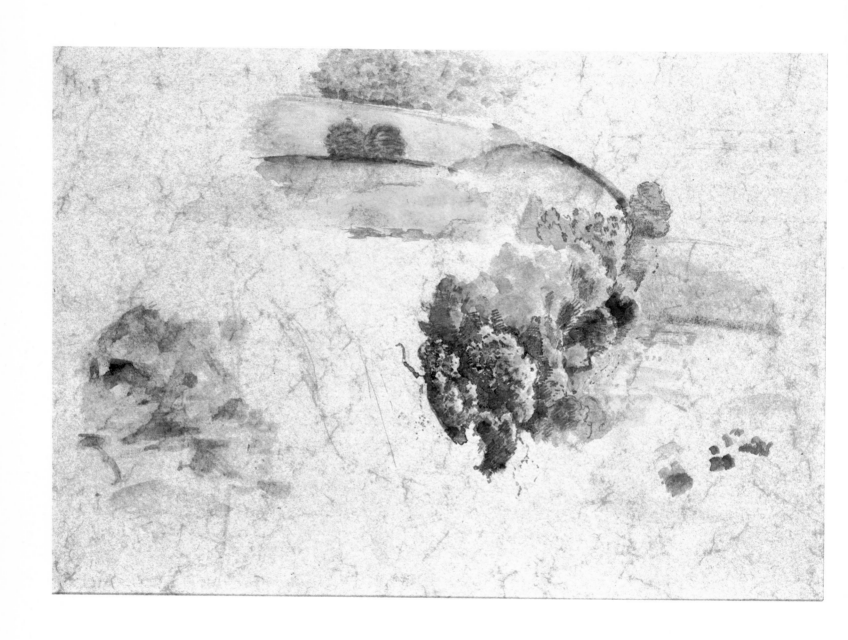

Six variations on Monte Calvello
(nos 115–20)

116 *Landscape at Monte Calvello, c.* 1972
Watercolour, 34.5 × 50 (13⅝ × 19⅝)
Collection Countess Klossowski de Rola

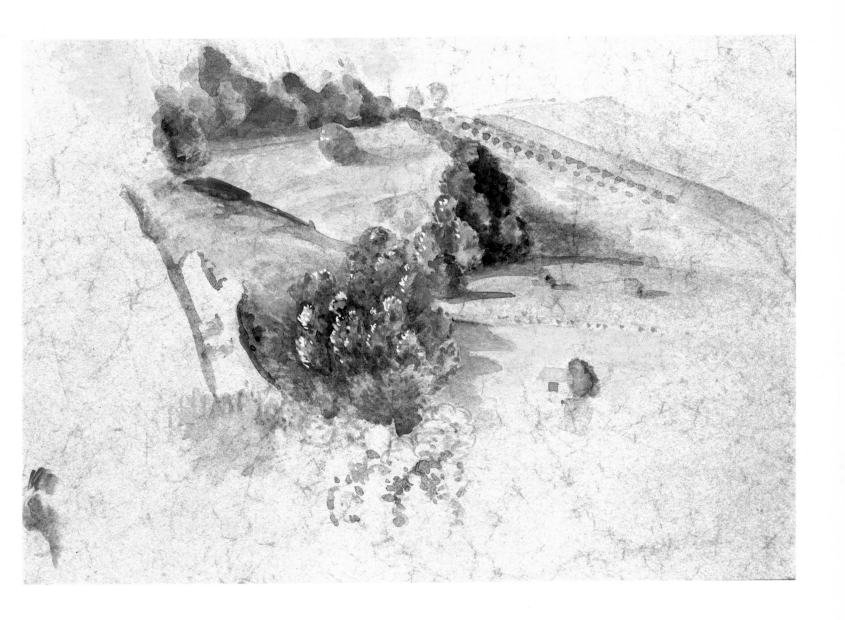

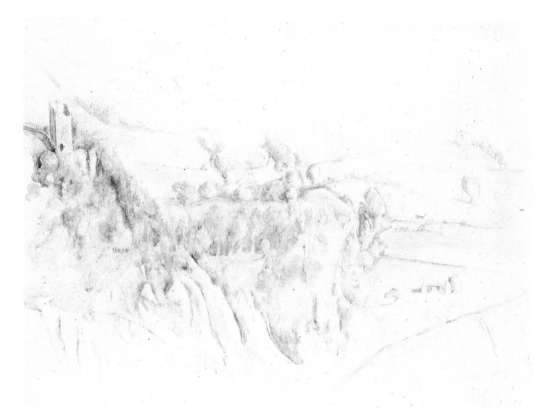

117 *Monte Calvello*, 1978
Watercolour, 68 × 92 (26¾ × 36¼)
Private collection, Switzerland

These four views of Monte Calvello are among the
artist's most remarkable recent landscapes. The
tower of the hill-top village and the sheer slopes
below have been transformed into a dream scene
comparable with the *kakemonos* of the Chinese
painter Lan Ying (also known as Lan T'ien-shu)
of the Wu school, 1578-post 1660. These different
drawings were to lead eventually to the great
Balthus painting *Monte Calvello* (1977–79,
reproduced in the catalogue of the 1980 Venice
Biennale, nos. 49–50).

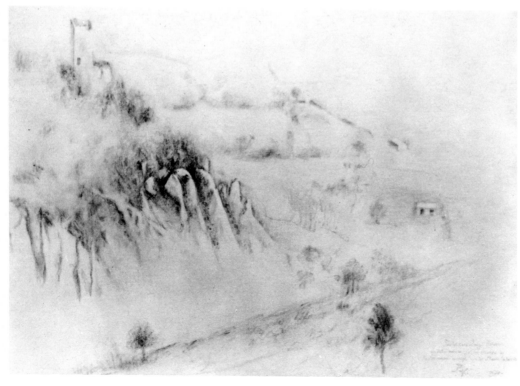

118 *Monte Calvello*, 1978
Pencil and charcoal, 70 × 100 (27½ × 39⅜)
Initialled, dated and dedicated bottom right
Private collection, Rome

See note to no. 117.

119 *Monte Calvello*, 1978
Charcoal, 70 × 100 (27½ × 39⅜)
Initialled, dated and dedicated in top right-hand
corner
Private collection, Rome

See note to no. 117.

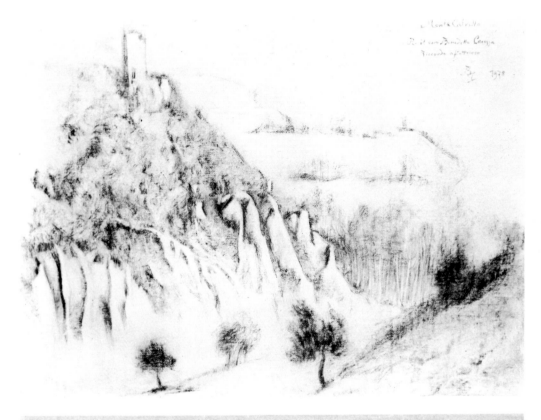

120 *Monte Calvello*, 1978
Charcoal, 70 × 100 (27½ × 39⅜)
Initialled, dated and dedicated bottom right-hand
corner
Private collection, Rome

See note to no. 117.

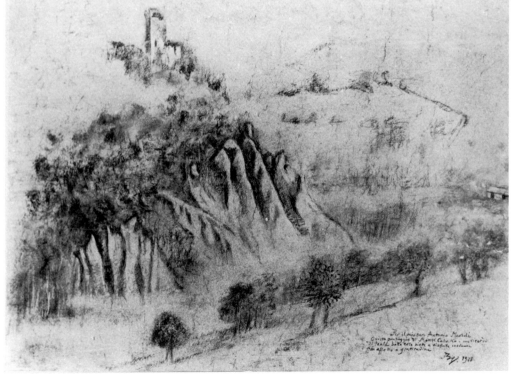

121 *Still-life: Bowl with Vegetables*, 1978
Pencil and watercolour, 35 × 47 (13¾ × 18½)
Initialled, dated and dedicated bottom right
Private collection, Rome

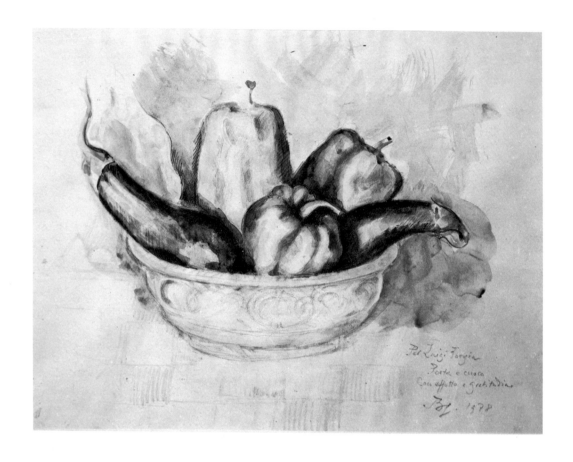

122 *Girl Asleep*, 1978
Pencil, 100 × 70 (39⅜ × 27½)
Signed below left
Private collection, Rome

123 *Seated Girl*, 1978
Pencil and charcoal, 100 × 70 (39⅜ × 27½)
Signed bottom left
Private collection, Rome

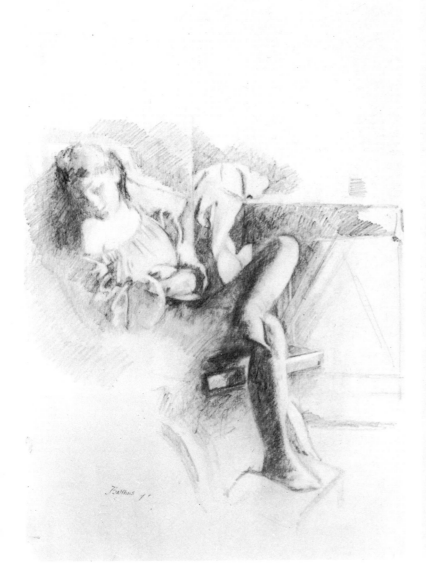

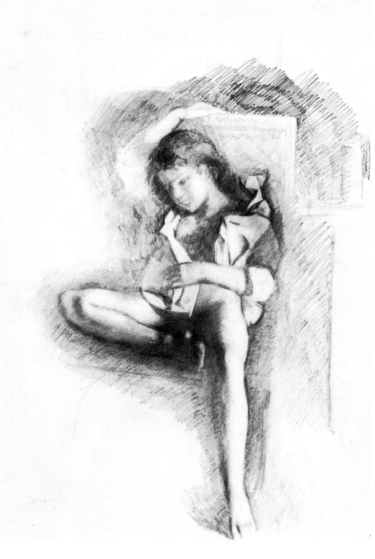

124 *Girl Asleep*, 1978
Pencil and charcoal, 70 × 100 (27½ × 39⅜)
Signed below left
Private collection, Rome

See also no. 131.

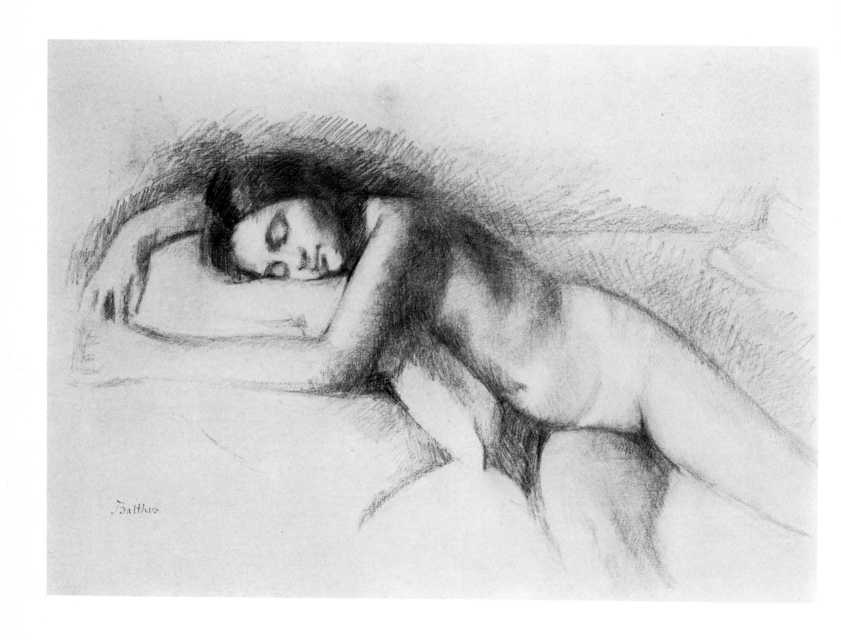

129 *Girl Stretched Out*, 1978
Pencil and charcoal, 70 × 100 (27½ × 39⅜)
Dedicated and initialled below left
Collection Sandro Manzo, Rome

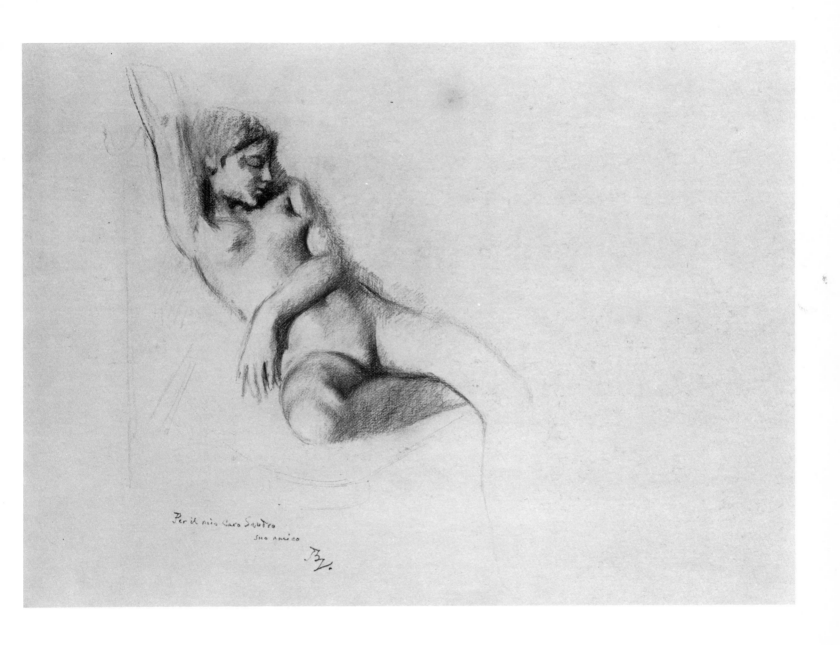

130 *Seated Girl, c.* 1976
Pencil and charcoal, 100 × 64 (39⅜ × 25¼)
Initialled below centre
Collection Claude Bernard, Paris

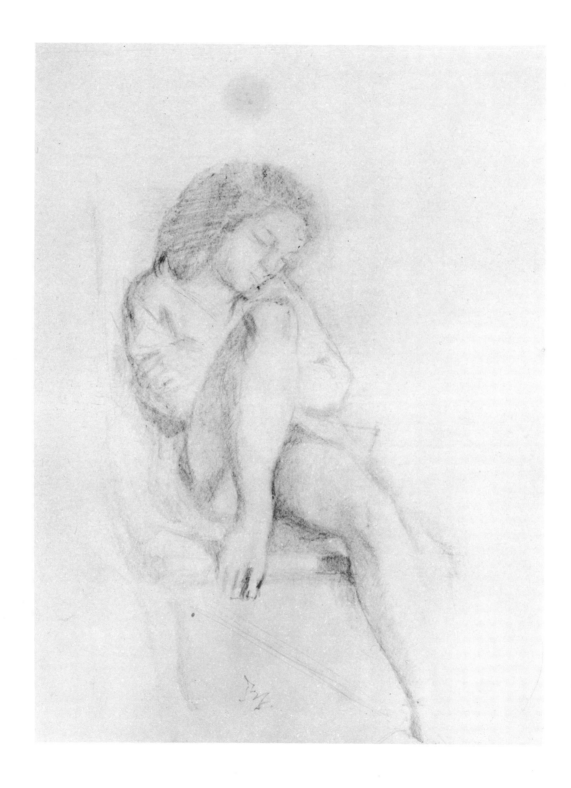

131 *Girl Asleep, c.* 1975
Pencil and charcoal, 70 × 100 (27½ × 39⅜)
Initialled bottom left
Private collection, Milan

Another drawing of the same subject, but with
more softly defined features, is in the collection of
Ira Young, West Vancouver. A private collection
in Rome contains a smaller study. See also no. 124.

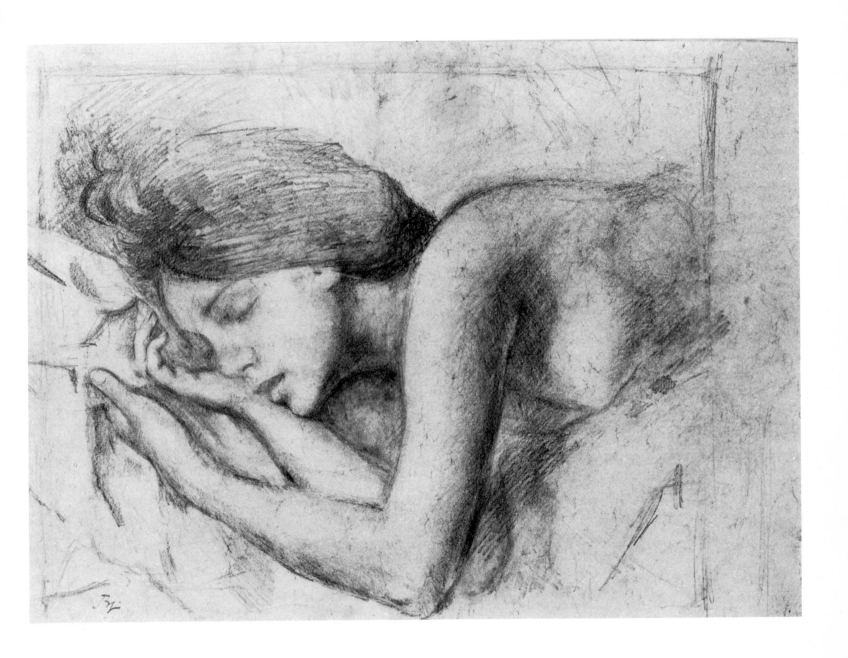

132 *Girl Asleep*, 1982
Pencil on ivory-coloured paper, 100.2 × 70.5
(39½ × 27¾)
Signed and dedicated above right
Collection Memmo Mancini, Rome

This takes up as a *d'après* the subject of
Sleeping Nude (1980, reproduced in the catalogue
of the Venice Biennale, nos 54–56). See also no.
95.

Bibliography

1921

R. M. Rilke, preface to Baltusz, *Mitsou: quarante images*, Erlenbach-Zürich, Leipzig, Rotapfel.

1934

A. Artaud, 'Exposition Balthus à la Galerie Pierre' in *La nouvelle revue française*, no. 248, May (review of the Galerie Pierre exhibition, 1934), English trs. in Russell, London 1968, p. 33.

E. Tériade, 'Aspects actuels de l'expression plastique' in *Minotaure*, Paris, no. 5, May, pp. 33, 48.

1935

Balthus, 'Illustrations pour "Les Hauts de Hurlevent"' in *Minotaure*, Paris, no. 7, June, pp. 60–61.

1936

A. Artaud, 'La pintura francesa joven y la tradicion' in *El Nacional*, Mexico, 17 June.

P. J. Jouve, *Urne*, Paris, G.L.M. (Repères series no. 18, with a drawing by Balthus).

1938

H. McBride, review of the Pierre Matisse Gallery exhibition, 1938, in the *New York Sun*, 26 March.

C. Burrows, review of the Pierre Matisse Gallery exhibition, 1938, in the *Herald Tribune*, New York, 27 March.

Review of the Pierre Matisse Gallery exhibition, 1938, in *Art Digest*, 1 April.

J. T. Soby, *Balthus*, exh. cat., Pierre Matisse Gallery, New York.

1939

B. Champigneulle, 'L'inquiétude dans l'art d'aujourd'hui' in *Mercure de France*, Paris, pp. 67, 86.

1940

M. Zahar, 'Balthus' in *The Studio*, London, vol. XIX, April, pp. 126–27.

1945

R. Char, 'Balthus ou le dard dans la fleur' in *Cahiers d'art*, Paris, nos 20–21, p. 199. See also 1981: R. Char.

E. Müller, 'Balthus' in *Labyrinthe*, Geneva, no. 13, 15 October, p. 11.

M. Praz, 'La voce nella tempesta' (1941) in *Motivi e figure*, Torino, Einaudi, Saggi, p. 175.

R. M. Rilke, 'Lettres à Balthus' in *Fontaine*, Paris, no. 44. See also 1951: R. M. Rilke.

1946

J. Lassaigne, 'Balthus' in *Arts*, Paris, no. 95, 29 November, p. 1.

P. Leyris, 'Deux figures de Balthus' in *Signes*, Paris, no. 4, pp. 83–87.

P. Loeb, *Voyages à travers la peinture*, Paris, Bordas, pp. 37–39.

1947

W. George, 'Balthus' in *Figaro-Littéraire*, Paris, 25 January.

L. F. Gruber, 'Balzac vu par douze artistes' in *Graphis*, Zürich, no. 20, pp. 310–11.

M. Raynal, *Peintres du XXᵉ siècle*, Geneva, Skira, p. 33.

1948

P. Eluard, 'A Balthus' in *Voir*, Geneva, Paris, Trois Collines, pp. 91–93.

R. Ironside, 'Balthus', in *Horizon*, London, 17, no. 100, April, pp. 263–67.

J. T. Soby, 'The Position of Balthus. Report from Paris', *Saturday Review of Literature*, New York, 15 August.

A. Watt, 'Balthus' in *Occident*, Paris, no. 2, January, pp. 20–29.

1949

M. Arland, *Chronique de la peinture moderne*, Paris, Corrêa, p. 19.

A. Camus, *Balthus*, exh. cat., Pierre Matisse Gallery, New York (reprinted in Russell, London 1968).

R. Huyghe, *Les contemporains*, Paris, Tisné (La Peinture Française series), p. 170.

Review of Pierre Matisse Gallery exhibition, 1949, in *Time*, New York, 28 March.

'Spotlight on Balthus' in *Art News*, New York, vol. XLVIII, March, p. 38.

1950

'Portrait' in *Art News*, New York, vol. XLVIII, January, p. 13.

1951

R. M. Rilke, *Letters to Merline, 1919–22* (a re-issue of 8 letters to Balthus originally published in *Fontaine*, 1945), London, Methuen.

1952

A. Camus, 'Peut-être' in *Verve*, Paris, vol. II, nos 27–28, p. 35.

C. Connolly, *Balthus and a Selection of French Paintings*, London, Lefevre Gallery.

R. Lacôte, *Tristan Tzara*, Paris, Seghers (with illustrations by Balthus).

G. S. Whittet, 'London Commentary' in *The Studio*, no. 143.

1955

R. Genaille, *La peinture contemporaine*, Paris, Nathan, p. 245.

R. M. Rilke, *Letters to Frau Gudi Nölke* ... (trs. from German), London, Hogarth, pp. 63, 69, 121, 124–25, 129.

1956

A. Berne Joffroy, 'Balthus' in *La nouvelle revue française*, no. 41, Paris, 1 May, pp. 929–30.

G. Bernier, 'Balthus' in *L'oeil*, Paris, no. 15, pp. 27–33. See also 1981: A. Berne Joffroy.

A. L. Chanin, 'Balthus – Joan Miró and His Daughter' in *The Metropolitan Museum of Art Miniatures: Paintings from the Museum of Modern Art*, New York, Series I, Book of the Month, no. 24.

M. Conil-Lacoste, 'Balthus' in *Le monde*, Paris, 11 February.

G. Hilaire, 'Complot contre Balthus' in *Arts*, Paris, 18 March.

G. Hilaire, 'Le monde absurde et enchanté de Max Ernst' in *Dimanche Matin*, Paris, 8 July.

L. Hoctin, 'Balthus' in *Arts*, Paris, February.

A. Jouffroy, 'Portrait d'un artiste: Balthus' in *Arts*, Paris, no. 557, February–March.

P. Klossowski, 'Balthus: Beyond Realism' in *Art News*, New York, vol. LV, no. 8, pp. 26–31.

'Parigi: Il ritorno di Balthus' in *Emporium. Rivista mensile d'arte e di cultura*, vol. CXXIII, no. 737, May, p. 227.

J. T. Soby, *Balthus*, exh. cat., The Museum of Modern Art, New York (reprinted in the *Museum of Modern Art Bulletin*, New York, vol. XXIV, no. 3, 1956–57, pp. 3–34) (31 paintings, 14 drawings, 27 illustrated).

'Timeless Moments of Balthus' in *Art News*, vol. LV, May 1956, p. 16.

1956–57

G. and R. Bernier, *The Selective Eye*, Paris, Lausanne, New York, Reynal, pp. 44–49.

1957

Balthus, exh. cat., Pierre Matisse Gallery, New York, January (17 paintings, 15 illustrated). P. Klossowski, 'Du tableau vivant dans la peinture de Balthus' in *Monde nouveau*, Paris, nos 108–09, March.

G. Limbour, 'La nouvelle Ecole de Paris' in *L'oeil*, Paris, no. 34.

J. T. Soby, 'Balthus' in *Modern Art and the New Past*, Norman, University of Oklahoma Press.

1958

Balthus, exh. cat., Galleria L'Obelisco, Rome, 12–18 May (10 paintings, 3 illustrated).

L. Carluccio, introduction to exh. cat., Galleria d'Arte Galatea, Turin, 10–30 April (10 paintings, 5 illustrated).

L. Carluccio, 'Dieci opere di Balthus alla Galleria Galatea' in *La Stampa*, Turin, 11 April.

L. Carluccio, 'Un pittore solitario' in *Gazetta del Popolo*, Turin, 17 April.

A. Dragone, 'Balthus alla Galatea' in *Il Popolo nuovo*, Turin, 17 April.

U. P., 'I quadri del pittore Balthus per la prima volta in Italia' in *Stampa sera*, Turin, 11 April.

C. Roger-Marx, 'Serait-ce un crime pour les peintres d'être fidèles aux corps, aux fleurs, aux ciels, à la vie?' in *Figaro-Littéraire*, Paris, 26 April.

1959

Y. Bonnefoy, 'L'improbable' in *Mercure de France*, Paris, pp. 49–74.

M. Jean, *The History of Surrealist Painting* (trs. from the French by S. W. Taylor) London, Weidenfeld and Nicolson, New York, Grove Press, 1960.

1960

M. Gauthier, 'Un Romain de la décadence' in *Aux écoutes*, Paris, 29 December.

W. George, 'Une fausse morte: l'Académie de France à Rome' in *Combat*, Paris, 19 December. See also 1959: M. Jean.

1961

G. Antonini, 'L'ultimo scandalo culturale provocato da Malraux. Chi è il pittore Balthus mandato a dirigere Villa Medici?' in *Il Gazzettino*, Venice, 4 April.

G. Antonini, 'Chi è il pittore Balthus prescelto a Parigi? Nemico dichiarato dell'accademismo il nuovo direttore della Villa Medici' in *Gazzetta del Sud*, Messina, 6 April.

'Balthus a Villa Medici' in *Successo*, Milan, February.

G. Bataille, *Les larmes d'Eros*, Paris, Pauvert.

G. Boudaille, 'Balthus contre Campigli' in *Les lettres françaises*, Paris, September.

P. Cabanne, 'Lettre ouverte à Balthus' in *Arts*, Paris, 22 February.

M. Conil-Lacoste, 'La VIIe Biennale de Turin rend hommage à Balthus et à Campigli' in *Le monde*, Paris, 1 November.

J. Lassaigne, 'Balthus' in *Peintres d'aujourd'hui, France-Italie*, exh. cat., Museo d'Arte Moderna, Turin.

M. D. M., 'Personali di Balthus e di Campigli nelle sale di Francia-Italia a Torino' in *L'Unità*, Milan, 3 October.

P. Mazars, 'A la recherche d'un directeur pour la Villa Medicis' in *Figaro-Littéraire*, Paris, 14 January.

C. Rivière, 'Pourquoi pas Balthus' in *Combat*, Paris, 23 January.

P. Schneider, 'Balthus et van de Velde' in *L'express*, Paris, 2 November.

M. Valsecchi, 'Italia-Francia' in *Arti*, Turin, pp. 123, 124.

1962

Y. Bonnefoy, 'Dualité de l'art d'aujourd'hui' in *Arts de France*, p. 291.

M. Gendel, 'H. M. the King of Cats, a Footnote' in *Art News*, New York, vol. LXI, no. 2, pp. 37–38.

J. Lassaigne, introduction to *Balthus, Paintings 1929–1961*, exh. cat., Pierre Matisse Gallery, New York.

A. Rewald, 'Interview avec Balthus' in *Gazette de Lausanne*, 8 December.

P. Waldberg, *Surrealism* (trs. from the French by S. Gilbert), Geneva, Skira.

1963

T. Hess, 'Draftsmanship as Dissection' in *Art News*, New York, vol. LXII, no. 8, p. 34.

J. Rewald, 'Thoughts on Drawings by Balthus' in *Balthus Drawings*. exh. cat., E. V. Thaw & Co., New York (55 drawings, 31 illustrated).

A. Watt, 'Balthus and Realism' in *The Studio*, London, vol. CLXVI, no. 846, pp. 144–47.

1964

J. Cassou, 'Balthus' in *Les peintres célèbres*, Paris, Mazenod, p. 50.

1966

G. Antonini, 'Alti onori per Balthus. La stagione a Parigi' in *Il Gazzettino*, Venice, 15 September.

H. Bouras, *An Exhibition of Balthus Drawings*, exh. cat., B. C. Holland Gallery, Chicago, 23 September – 18 October (16 illustrated).

A. M. Clark, 'Balthus, The Living Room' in *The Minneapolis Institute of Arts Bulletin*, vol. LV, pp. 53–56.

G. Coste, 'Balthus, un pas de plus vers la consécration' in *Connaissance des arts*, no. 170, April, pp. 58–65 (texts by P. Waldberg, J. Cassou, M.-L. de Noailles, F. Labisse, M. Rheims).

G. Gillet, 'Balthus, un seigneur solitaire' in *La Galerie des Arts*, Paris, no. 33, April.

J. Lord, introduction to *Alberto Giacometti and Balthus Drawings*, exh. cat., New York, Albert Loeb and Krugier Inc. Gallery, *Taurus*, no. 2, New York (55 drawings by Balthus).

G. Metken, 'Traum und Eros, Balthus im Musée des Arts Décoratifs, Paris' in *Die Weltkunst*, vol. XXXVI, no. 12, p. 594.

G. Picon, 'Les dalles de Venise' in *Balthus*, exh. cat. Musée des Arts Décoratifs, Paris (51 paintings, 34 illustrated).

1967

C. Estienne, 'Balthus, The Solitary Scandal' in *Art News*, New York, vol. LXVI, no. 3, pp. 39–41, 47.

M. Peppiatt, 'Balthus' in *Réalités*, Paris, October.

J. Russell, 'Master of the Nubile Adolescent' in *Art in America*, New York, vol. LV, no. 6, pp. 98–103.

P. Waldberg, 'The Turkish Room – La Chambre Turque' in *Balthus, La chambre turque, Les trois soeurs, Drawings and Watercolours*, exh. cat., Pierre Matisse Gallery, New York (4 paintings, 27 drawings and watercolours, 31 illustrated).

1968

J. Russell, *Balthus*, exh. cat., Tate Gallery, London (60 paintings, 26 drawings and watercolours, 72 illustrated).

P. Sers, 'Balthus le chat' in *Revue d'esthétique*, no. 1, pp. 62–69.

1969

V. Zurlini, 'Quella sera romana con Balthus' in *Il Dramma*, Turin, no. 5, February, pp. 10–12 (reprinted as a booklet for private circulation only; 150 numbered copies with a portrait of Balthus and etchings by Renato Guttuso and Reggio Emilia, Prandi, June 1975).

1971

I. Arnaldi, 'Balthus il Baronetto ovvero il sadismo dell'ambiguità' in *Il Margutta*, Rome, nos 11–12, pp. 25–26.

A. Artaud, 'La jeune peinture française et la tradition' in *Messages révolutionnaires*, Paris, Gallimard (originally published in Spanish – see 1936: A. Artaud).

J. Leymarie, introduction to *Balthus, dessins et aquarelles*, exh. cat., Galérie Claude Bernard, Paris (67 drawings and watercolours, 35 illustrated), printed in 1976.

1972

G. Charensol, 'Balthus et Gromaire' in *Revue des deux mondes*, no. 1, pp. 168–69.

1973

'Balthus' in *L'oeil*, nos 217–18, pp. 62–63.

A. Camus, introduction to *Balthus*, exh. cat. (Pierre Matisse Gallery, 1949) reprinted in French as introduction to *Balthus/Cantini*, exh. cat., Museo Cantini, Marseilles (48 paintings, 25 drawings and watercolours, 68 illustrated).

Enciclopedia dell'arte, Milan, Garzanti.

J. Leymarie, preface to *Balthus/Cantini*, exh. cat. (see 1973: A. Camus).

G. C. Marmori, 'Nel pianeta delle bambine' in *L'Espresso*, Rome, 19 August.

1975

Balthus, peintures, aquarelles, dessins, exh. cat., Galérie Arts Anciens, Bevaix.

A. Pieyre de Mandiargues, 'Balthus, je me souviens' in *XXe siecle*, vol. XXXVII, pp. 63–67. See also 1969: Zurlini.

1976

See 1971: J. Leymarie.

1977

P. Bigongiari, 'Balthus a Firenze' in *23° premio del Fiorino, Biennale internazionale d'arte*, exh. cat., Palazzo Strozzi, Florence.

F. Fellini, *Balthus*, exh. cat., Pierre Matisse Gallery, New York, 1977 (reprinted in exh. cat., *Balthus*, Biennale, Venice, 1980, and in *Balthus, Barelier, Rouan*, exh. cat., Ratilly, Centre d'Art Contemporain, 1981).

1978

'Due giovanissime donne che sognano semisvestite' in *La Repubblica*, Rome, 2 July.

J. Leymarie, *Balthus*, Geneva, Skira.

1979

A. Berne Joffroy, 'Cette exposition . . .' in *L'aventure de Pierre Loeb, La Galérie Pierre, Paris 1924–1964*, Musée d'Art Moderne de la Ville de Paris, 7 June – 16 September, Musée d'Ixelles, Brussels, 4 October – 23 December, p. 10 (4 paintings and 2 drawings by Balthus, nos 28 and 32 in this catalogue, were exhibited).

A. Kingsley, 'The Sacred and Erotic Vision of Balthus', in *Horizon*, New York, December, pp. 27–35 (9 illustrations).

La délirante. Revue de poésie, Paris, no. 7 (the drawing on the dust jacket and the illustrations on pp. 22, 27, 31, 38, 43, 140, 170, 171, 175 are by Balthus).

1980

'Balthus' in *Petit journal de l'exposition Les Réalismes 1919–39*, Centre Georges Pompidou, Paris, p. 14.

P. Bigongiari, 'Una grande occasione d'incontro e di scoperta a Venezia. Balthus nella luce di Piero' in *Il Popolo*, Rome, 26 July.

P. Bigongiari, *Dal barocco all'informale*, Bologna, Nuova Casa Editrice, ed. L. Cappelli, pp. 323–33, figs VII, VIII.

G. Cacciavillani, 'La mostra di Balthus a Venezia nell'ambito della Biennale. In un transito feroce e infido la magia della sua pittura' in *Il Piccolo*, Trieste, 10 June.

P. Chessa, 'Balthus nel paese delle meraviglie' in *L'Europeo*, Milan, 10 June.

M. Conadini, 'Alla Biennale di Venezia, Balthus: un pittore tutto da vedere' in *Giornale di Bergamo*, 6 August.

L. Danelutti, 'Balthus: E la laguna arrossisce di innocenza' in *Il Piccolo Illustrato*, Trieste, 26 July.

F. Fellini, introduction to *Balthus*, exh. cat., Venice Biennale, Milan, Electa (56 colour illustrations). See also 1981: F. Fellini.

E. Fezzi, R. Guasco, 'La sovrana presenza dell'inattuale Balthus, in *Nuova Rivista Europea*, Milan, 18 July – September, p. 100.

Grands maitres contemporains, exh. cat., Le Point, Galérie d'Art Moderne, Monte-Carlo, 11 December – 10 January no. 1 (1 drawing).

J. Leymarie, introduction to *Balthus*, exh. cat., Venice Biennale, Milan, Electa (56 colour illustrations).

J. Leymarie, 'Balthus' in *La Biennale de Venezia*, Venice, pp. 213–20.

P. Maestri, 'Sur la lagune: Balthus' in *Domus*, Milan, October.

G. Mascherpa, 'La preziosa antologia alla Biennale. Il grande Balthus poeta solitario' in *Avvenire*, Milan, 13 June.

L. Meneghelli, 'Balthus: nel nudo un freddo enigma' in *Il giornale di Vicenza*, 6 June.

W. Paris, 'La mostra di Balthus fiore allpocchiello della Biennale. Le Fanciulle maliziose come angeli invecchiati' in *La Nuova Sardegna*, Sassari, 3 October.

J. Perl, 'Balthus' in *Arts Magazine*, New York, September, p. 19.

R. Sertoli Salis, 'In margine alla Biennale d'arte di Venezia. La montagna di Balthus e quella di Usellini' in *Eco della Valle*, Sondrio, 30 September.

V. Sgarbi, 'Un decadente dal nome antico' in *Il Mattino*, Naples, 30 July.

G. Szabo, *Balthus Drawings*, exh. cat., Gertrude Stein Gallery, New York, 1 May – 30 June.

G. Testori, 'Con la mostra alla Biennale, la verità sul conto di un maestro. Svelato il mistero Balthus' in *Corriere della Sera*, Milan, 1 July.

L. Trucchi, 'Il pittore russo-parigino alla Biennale. Le tremende bambine dell'inquieto Balthus' in *Il Giornale nuovo*, Milan, 13 June.

M. Venturoli, 'Balthus e le "teen"' in *Playmen*, Rome, September.

1981

Balthus in Chicago, exh. cat., Museum of Contemporary Art, Chicago, n.d. (6 paintings, 34 drawings, 11 illustrated).

A. Jouffroy, 'Portrait d'un artiste: Balthus' in *Paris/Paris, 1937–1957*, exh. cat., Centre Georges Pompidou, Paris, pp 242–43.

R. Char, 'Balthus ou le dard dans la fleur' in *Paris/Paris, 1937–1957* (see 1981: A. Jouffroy), p. 243 (reprint of the 1945 article).

F. Fellini, introduction to *Balthus*, exh. cat., Venice Biennale 1980, reprinted in *Balthus, Barelier, Rouan* (see 1981: J. Leymarie).

J. Leymarie, introduction to *Balthus, Barelier, Rouan*, exh. cat., Ratilly, Centre d'Art Contemporain, Treigny, Yonne, 28 June – 14 September (8 paintings, 9 drawings, 4 illustrated).

R. Pomeroy, 'Balthus' in *Art in America*, New York, summer issue, p. 5.

1982

Balthus and Twombly, exh. cat., Thomas Amman Fine Art, Zürich.

G. di Genova, *Il fantastico erotico*, Bologna, Bora, p. 24.

Livres illustrés. Dessins et estampes, Paris, Pierre Berès cat. 72, nos 248, 249.

W. Wiegand, 'Balthus im Garten der Lüste' in *Frankfurter Allgemeine Magazin*, Frankfurt, vol. 97, 8 January.

Acknowledgments

The author and the organizers of the 1982 Spoleto exhibition are profoundly grateful to all the individuals and institutions who have lent their works for exhibition and reproduction here, and who are acknowledged individually in the captions. Particular thanks are due to Claude Bernard, Sandro Manzo, Pierre Matisse, Laura Mazza and Sabine Rewald for their unstinting help throughout the project. They would also like to express their gratitude to all those who have helped in various other ways, especially Minna Heimbürger Ravalli, Vincent Garzero and the organizers of the Festival dei Due Mondi.

Photographic Acknowledgments
Jacques Bétant, Lausanne; Leonardo Bezzola, Berne; Geoffrey Clements, New York; Pasquale de Antonis, Rome; Alfio di Bella, Rome; Patrick W. Goetelen, Geneva; Jacqueline Hyde, Paris; Eric Pollitzer, New York; Walter Rosenblum, Lond Island City; Steven Sloman, New York; The Museum of Modern Art, New York. Photograph by Man Ray © by ADAGP, Paris 1982.